Helen Van Wyk's Favorite
COLOR RECIPES

HELEN VAN WYK'S FAVORITE COLOR RECIPES
by Helen Van Wyk

Published by Art Instructions Associates
2 Briarstone Road, Rockport, Massachusetts 01966

Parts of this book were published earlier as
SUCCESSFUL COLOR MIXTURES by Helen Van Wyk.

ISBN: 0-929552-10-5

99 98 97 4 3

Distributed to the book trade and art trade in the U.S. by
North Light Books, an imprint of F&W Publications
1507 Dana Avenue, Cincinnati, Ohio 45207
Telephone: (513) 531-2222, (800) 289-0963

Edited by Herb Rogoff
Design & Production by Bridges Design
Design Assistant: Laura Herrmann
Project Coordinated by Design Books International
5562 Golf Pointe Drive, Sarasota, FL 34243

Printed and Bound in Singapore

BOOKS BY HELEN VAN WYK

CASSELWYK BOOK ON OIL PAINTING

ACRYLIC PORTRAIT PAINTING
 (OUT OF PRINT)

SUCCESSFUL COLOR MIXTURES

PAINTING FLOWERS THE VAN WYK WAY

PORTRAITS IN OIL THE VAN WYK WAY

BASIC OIL PAINTING THE VAN WYK WAY
 (REVISION OF CASSELWYK BOOK ON
 OIL PAINTING)

YOUR PAINTING QUESTIONS ANSWERED
 FROM A TO Z

WELCOME TO MY STUDIO

WELCOME TO MY STUDIO (NEW REVISED
 EDITION)

MY 13 COLORS AND HOW I USE THEM

COLOR MIXING THE VAN WYK WAY

Helen Van Wyk's Favorite COLOR RECIPES

Helen Van Wyk

Art Instruction Associates, Rockport, Massachusetts
Distributed by North Light Books, Cincinnati, Ohio

Table of Contents

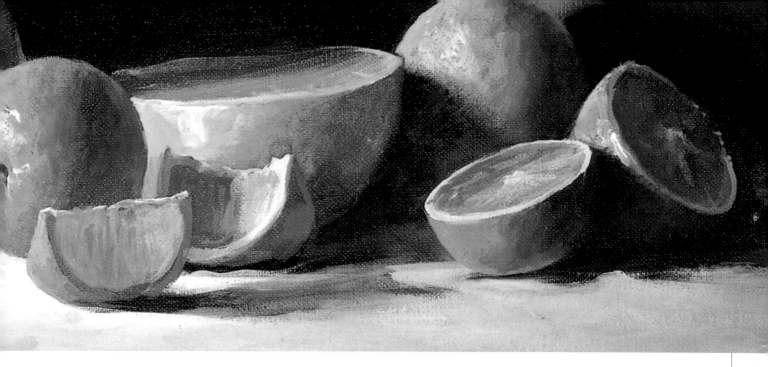

Introduction

Shortly after her arrival in Rockport, Mass., from her native New Jersey, Helen Van Wyk experimented with a new form of painting lessons which she called *color mixing recipes.* Actually, she was forced into doing this because, originally, she had a cook book in mind. Her initial idea was to have women artists she knew, mostly students and former students, submit a favorite recipe of theirs, along with one of their paintings to be reproduced. Her title for this book was to be, *The Creative Woman's Cook Book.*

Her first step was to find out whether or not she could get enough cooking recipes and pictures of paintings for the book. She selected ten names and tried the proposition out on them. The response was amazing; all of them came back with enthusiastic affirmation. Among the replies was a note from a former student who had moved to Macon, Georgia. She would be happy, she wrote, to provide Helen with her plum preserve recipe, as Helen had specifically requested. She also said she'd be pleased and flattered to have one of her paintings appear in a book written by Helen Van Wyk. "But," her letter went on, "I wonder why you are writing a cook book and not one on painting instruction?"

At that time, Helen was already the author of *The Casselwyk Book on Oil Painting,* which she had published herself ten years earlier, and which she considered to be the consummate book on oil painting. Furthermore, Watson-Guptill had just published her second book, *Acrylic Portrait Painting.* As a result, she never gave any thought to writing another book on painting instruction.

The cook book concept, however, gnawed at her. Why not recipes that will teach how to mix colors for portraits, florals, still lifes and landscapes? As far as she knew, it had never been done before.

She started writing the recipes, and what a formidable feat it was! Helen was able to mine from her knowledge the color mixtures and procedures to paint a wide array of subjects in the vast world of painting. It was a virtuoso performance because there wasn't a single subject that was beyond her understanding of its structure and color makeup. I edited the recipes, and

then typed the final copy for the printer on an IBM Executive. Meanwhile, we gathered up Helen's list of students she had taught in workshops around the country and also the names of many hundreds who came to her demonstrations when she toured for Grumbacher. We sent letters explaining this new teaching concept and offered the "book" in sixteen, three-hole-punched sheets for $2.50. The loose leaf sheets, we explained, could be put into a binder to make working with each one that much easier. The sixteen-page section contained four each of portraits, still life, floral and landscape instruction.

The results were incredible; orders poured in from all over for this first section and, as they came off press, succeeding sixteen-page sections. This was all the more remarkable when one considers that there were no illustrations with the instructions and all of the printing was done in black and white. As more sections were added, the shipping of them became a nightmare, and so, we decided to put all of the recipes into one big spiral-bound volume under the title, *Successful Color Mixtures*.

Now, more than twenty years after the first type-written section was published, you are holding in your hands *Helen Van Wyk's Favorite Color Recipes*.

If this is your initial acquaintance with these recipes, you will soon discover how important Helen's color mixing techniques will be to your painting success. If you are among the more than 40,000 people who had already purchased these recipes in their various forms, you will enjoy having this revised full-color collection of the most popular color mixing recipes by Helen Van Wyk.

It is truly a time for celebration. But it is also a time to be sad; Helen is not here to bask in the sunshine of this incredible accomplishment, having succumbed to the cancer that had consumed the last four years of her life. In December 1994, Helen Van Wyk died at the too-young age of 64.

Herb Rogoff
Rockport, Massachusetts

Acknowledgment

As many of you are aware, *Successful Color Mixtures*, the precursor for this book, was printed entirely in black and white. When we decided to publish a clothbound edition, fully illustrated in color, Helen Van Wyk was to do the extra artwork for this new edition. She never got the opportunity. We, therefore, called upon Joan Lord of Schenectady, N.Y., because Joan studied with Helen and is familiar with *Successful Color Mixtures* as a teaching tool. Now a painter, teacher and demonstrator in her own right, Joan Lord has been teaching the "Van Wyk" method for years.

Anita Elizabeth Kertzer, another artist much admired by Helen, has helped us with additional illustrations. Anita is a well-known portrait painter in her native Ottawa, Canada, also teaching classes there as well as in Longboat Key, Florida, where she makes her winter home.

The publishers are indebted to Joan and Anita for their invaluable contributions to this book. Since we feel that our readers will want to know which of the illustrations are to be credited to both Joan and Anita, we have placed a small "*JL*" and "*AEK*" on all illustrations each had done.

A Basic Palette of Colors

The word palette, in painting, has two meanings. First, a palette is a device on which the artist squeezes out his paints; second, a palette is a list of the colors that an artist uses.

The palette, as a place to find the color you want, becomes your most personal and important tool. As an artist, you are fortunate, for you have the chance to try out all the decisions before you commit them to canvas. This is what your palette is for. On it you decide the tone, the intensity, and the hue of a color, as well as experimenting with the thickness or thinness your paint has to be. You can get a feel of the paint as it might flow onto the canvas by using some preliminary strokes on your palette.

Many painters, especially beginners, think their palettes are just places to "store" their paints as they use them. Its

function goes deeper than that. Your palette's a "thinking place." It should be cared for very well. I've seen a lot of talent left on a dirty, disorganized palette, never to find a picture to record it.

Basically, a palette should be neat and well organized. On this palette, the artist squeezes out his assortment (palette) of colors. A good way to start is to squeeze out white at one end and black at the other. I've listed below the basic colors for you to place between the two colorless extremes.

You may find, as you go through this book, that I've referred to colors that don't appear on the list that follows — which is a basic palette of the very least colors you'll need. Additional ones make painting easier. You can always add those extra colors you feel you need.

A BASIC PALETTE

1. White. Any white. I prefer Zinc White because it's clean tinting and slow drying. Sadly, it's been increasingly difficult today to find a Zinc White that's soft and buttery.

2. Thalo Yellow Green. A light yellow green that I group with my yellows.

3. Cadmium Yellow Light. The lightest, brightest yellow.

4. Cadmium Orange. A convenient bridge between yellow and red.

5. Cadmium Red Light. The only Cadmium Red that I use.

6. Grumbacher Red. The closest tubed red to spectrum red.

7. Yellow Ochre. A yellow often found in nature. Can't be made or mixed easily.

8. Raw Sienna. Darker, more orange than Yellow Ochre.

9. Light Red. A red often found in nature. Can't be made or mixed easily.

10. Burnt Umber. A color that records a warm, dark tone in nature.

11. Burnt Sienna. An indispensable dark orange.

12. Alizarin Crimson. A source of all the tones of violet when mixed with gray.

13. Thalo Blue. The most versatile blue because of its tone and intensity.

14. Thalo Green. For the same reasons as Thalo Blue.

15. Ivory Black. A way to darken dark colors. I like Ivory Black because it's transparent and clean and won't overtake a color; it just darkens it.

Value Scale

All color has a tone value as well as an intensity and a hue. Getting the right tone value of a color is the most important factor in painting. Using this Value Scale will help you get the right tone of any color. The Value Scale ranges from white to black with four numbered gradations in between.

All six colors of the spectrum — yellow, orange, red, violet, blue and green — have a tonal range that's as extensive as this Value Scale. For example: The tone of yellow can be as light as a lemon (#2) and as dark as an oak table (#8), which is really a dark yellow (Burnt Umber) rather than a brown.

In order to help you get the right tone of the color in several of the *Color Recipes,* I'll mention a number to represent the value of a color. This number — somewhere between #2 and #8 on the Value Scale — will give you a visual picture of the tone I'm referring to.

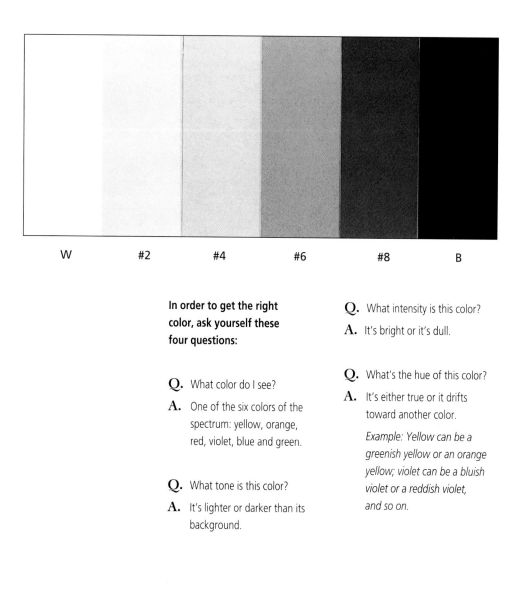

W #2 #4 #6 #8 B

In order to get the right color, ask yourself these four questions:

Q. What color do I see?

A. One of the six colors of the spectrum: yellow, orange, red, violet, blue and green.

Q. What tone is this color?

A. It's lighter or darker than its background.

Q. What intensity is this color?

A. It's bright or it's dull.

Q. What's the hue of this color?

A. It's either true or it drifts toward another color.

Example: Yellow can be a greenish yellow or an orange yellow; violet can be a bluish violet or a reddish violet, and so on.

The Five Basic Shapes

These are the five values and shapes that are used in all Color Recipes.

LIGHT SOURCE

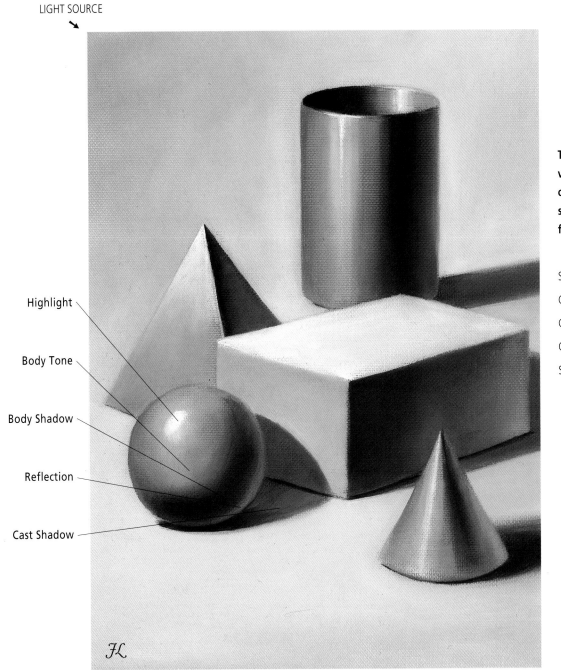

Highlight

Body Tone

Body Shadow

Reflection

Cast Shadow

These same five values show up on the other shapes. Can you find them?

SPHERE

CUBE

CYLINDER

CONE

SOLID TRIANGLE

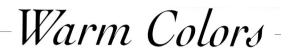

Warm Colors

THE REDS

The color red can be very difficult to paint if you use the red violets as red. Many tubed reds turn violet when mixed with white. When this happens the red should be mixed with a lighter red or an orange and then lightened with white. So, please — take careful note of the colors that I list as red.

The reds are: **Cadmium Red Light,** any color that's called **Vermilion, Grumbacher Red, Venetian Red, Light Red** (English Red), **Mars Red,** and **Indian Red.**

NOTE: On many tubes of Cadmium Red you'll find the word "Barium." This is a description of what it's made of and not a description of its hue.

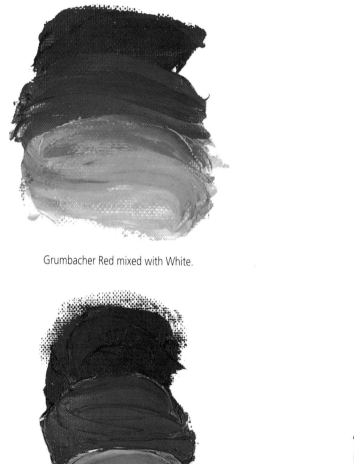

Grumbacher Red mixed with White.

Cadmium Red Light mixed with White.

Cadmium Red Medium mixed with White.

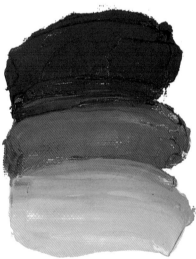

Cadmium Red Deep mixed with White.

Cadmium Red Medium and Cadmium Red Deep are shown tinted with white. They may seem to be usable reds in the mass tones, but with the addition of white, they indicate a definite muddy violetish tint-out, thus reducing their effectiveness. Compare them with the cleaner tinting, more brilliant Cadmium Red Light, which is far more versatile as a bright red. While Cadmium Red Light does lean towards orange, Grumbacher Red, seen tinted with white, is the closest you'll find to a neutral red.

CADMIUM RED LIGHT.

Whenever a bright red is called for in *Color Recipes,* this is the red that I recommend. This color varies in hue tremendously according to who manufactures it. You can use any of them. And you may substitute any of the vermilions for Cadmium Red Light; NEVER, NEVER, NEVER use Cadmium Red Medium or Cadmium Red Deep as substitutes. These are very, very poor in admixture with white. If you are going to use them, they have to be considered a violet. I'd never have either one on my palette for any reason. These two Cadmiums are the culprits on the amateur's palette because he is fooled by the way these reds look as they come out of the tube; they seem to be clear and clean. They're not! They're dark. And when lightened with white, they turn dull, bruised-looking, and unnatural. Besides — they're very expensive.

GRUMBACHER RED.

As much as I criticize and deplore the use of Cadmium Red Medium and Cadmium Red Deep, this is how much I'll praise and encourage the use of Grumbacher Red. This color is the proprietary product of M. Grumbacher, just as other manufacturers make colors that bear *their* proprietary names for one similar in makeup and hue. Chinese Vermilion is also similar in hue but most certainly not in price; Chinese Vermilion will cost you five times more than Grumbacher Red will. Grumbacher Red is permanent, and can withstand additions of lots of white without turning dull or orangey. It's a substitute for spectrum red. Mixed with Alizarin Crimson, it's a darker, rich red. It is important in flesh mixtures in admixture with yellow and white. And mixed with Chromium Oxide Green and black and white, it makes a lovely gray. When painting apples, or the color of Old Glory, you can't do without Grumbacher Red.

VENETIAN RED AND LIGHT RED (English Red).

Very similar and can be used interchangeably in all the *Color Recipes* in which any one of them is mentioned. Since this hue can be made by mixing Cadmium Red Light, Burnt Umber, and a touch of white, you can do without any one of them on a basic palette. Falling into the description of "earth" colors, they're the least expensive pigments. So why mix colors to make them? This color is a portrait painter's standby.

MARS RED AND INDIAN RED.

Of these two, Indian Red is more versatile. Mix Indian Red and Ivory Black and you'll find a nice dark warm color for backgrounds and warm accents to show depth in open windows and doors. A touch of Indian Red mixed with Alizarin Crimson makes a dark red that covers well. Mars Red is very opaque and very violet.

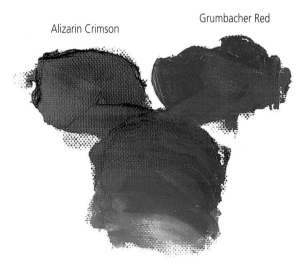

Alizarin Crimson · Grumbacher Red

When mixed with Alizarin Crimson, Grumbacher Red becomes a darker, rich red.

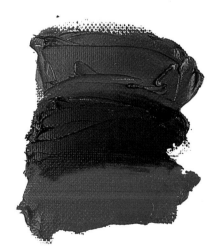

Grumbacher Red mixed with Chromium Oxide Green will make some pleasant-looking grays.

Warm Colors

THE YELLOWS

All of our *Color Recipes* refer to working with oil colors. As for painting in watercolor, most of the *Color Recipes* can be used. Keep in mind, though, that the painter must substitute water and his white paper for the white paint that's mentioned in the *Color Recipes.*

Some of the more common bright yellows are: **Lemon Yellow; Cadmium Yellow Pale; Cadmium Yellow Light: Cadmium Yellow Medium;** and **Thalo Yellow Green.** (The names Hansa, Barium, and Chrome describe the make-up of the paint rather than what the color is. For instance, Hansa Yellow Light and Cadmium Yellow Light will react in admixture very much the same. However, in this book we only work with the Cadmium colors to prevent any undue confusion among our artist-readers).

LEMON YELLOW.

A light yellow with a slight greenish hue. Usually a rather stiff consistency. Not a versatile yellow because its color can be matched by putting a touch of green into Cadmium Yellow Light.

CADMIUM YELLOW PALE.
A light yellow that's close to Cadmium Yellow Light. Can be used in all *Color Recipes* that call for Cadmium Yellow Light. Although similar to Cadmium Yellow Light, this yellow seems weaker in admixtures.

CADMIUM YELLOW LIGHT.
The most versatile light, bright yellow. Mixed with a touch of any green it makes a more sunlit green. Need brighter sunlight? Add some white. Mix with Ivory Black for olive greens; mix with any red and white to get flesh colors. CAUTION: Seldom used "pure" out of the tube. EXCEPTION: Many yellow flowers and other things that are light and bright.

CADMIUM YELLOW MEDIUM.

A darker version of Cadmium Yellow Light.Handy color to have on palette. Not as essential as Cadmium Yellow Light; can be approximated by mixing a little Cadmium Orange into a lot of Cadmium Yellow Light.

THALO YELLOW GREEN.
A very bright yellow green. A beautiful color to ease the pain of working with sunlit fields, trees. etc. Its more subtle uses: in portraiture, with Alizarin Crimson and white for flesh; with Cobalt Violet or Manganese Violet and Ivory Black and white for backgrounds; mixed with Ivory Black and white for a luminous gray; with Burnt Sienna for rich ambers and golds. It's a substantial color to have on your palette. It's great fun too!

Thalo Yellow Green Alizarin Crimson

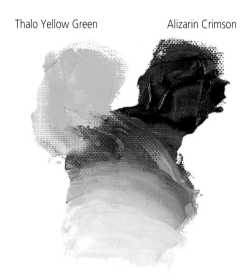

As strange as it may seem, upon looking at the two colors, Thalo Yellow Green when mixed with Alizarin Crimson will produce plausible flesh colors.

Cadmium Yellow Light

Cadmium Orange

Cadmium Yellow Medium can be approximated by mixing a little Cadmium Orange into a lot of Cadmium Yellow Light.

Some of the duller, darker yellows are: **Naples Yellow, Yellow Ochre, Mars Yellow; Raw Umber; Raw Sienna; Mars Brown;** and **Burnt Umber.** These colors are often referred to as brown, tan, beige, sand, bone, etc.

NAPLES YELLOW.

A medium bright yellow. Not a practical color for your palette because it can be matched by mixing Yellow Ochre, white, and some Cadmium Yellow Light. This color is very opaque: it will dominate any color it's mixed with. This is a characteristic of other opaque colors such as Chromium Oxide Green and all the Mars colors.

YELLOW OCHRE.

A medium-toned yellow. An indispensable color to get an array of colors such as tan, beige, bone, sand, ecru, etc. Mixed with a slight amount of any green will give you muted greens. Mixed with red and white will give you flesh colors. Lighten with white; brighten with Cadmium Yellow Light.

MARS YELLOW.

A very opaque color close to the hue of Yellow Ochre. Not versatile in admixture. Better to use Yellow Ochre.

RAW UMBER.

A dark dull color that can be classified as a yellow. Usually thought of as brown. Mistakenly used as a shadowing agent, and becomes the villain of many muddy pictures. Should only be used to represent things that are described as brown. Extremely transparent. Has a greenish hue. In admixture, not as strong as the more substantial Burnt Umber.

RAW SIENNA.

A darker, more orange version of Yellow Ochre. Very transparent. Same hints about Yellow Ochre apply. Can omit from a very basic palette since it can be somewhat matched by mixing Cadmium Yellow Light and Burnt Umber. To get the full volume and beauty of the colors in nature Raw Sienna can be a great friend.

MARS BROWN.

A toasty brownish color. Similar to Burnt Sienna but is very opaque. Not very versatile.

BURNT UMBER.

A dark warm brown. A must if you want dark, rich, warm colors. Mixed with white, makes tan; mixed with Ivory Black and white, makes warm gray; mixed with the Cadmium Yellows, makes greenish yellow hues; and makes any green more "forest-like." Add Burnt Umber to Alizarin Crimson for the darkest version of a warm color that's possible to mix.

THE ORANGES

The artist can become very confused by all the colors available on the dealers' shelves and also by some bizarre color theories and definitions that are found in many art books. My analysis of color and its use is logical, practical, and down to earth. My color information may be simplified, but it's by no means incomplete.

Here are the colors that should be classified as orange: **Cadmium Orange, Cadmium Yellow Orange, Cadmium Yellow Deep** (any color that's marked "Chrome" can be considered to be comparable to Cadmium in color hue), **Burnt Sienna,** and **Flesh.**

In color theory, orange is an admixture of a yellow and a red. The hue of orange, therefore, can tip toward yellow or toward red. Because of this, Burnt Umber, which is analyzed as a yellow, can also be regarded as an orange. For this same reason, Raw Sienna and Cadmium Red Light can also be thought of as orange.

WHY IS IT SO IMPORTANT TO CLASSIFY EACH COLOR?

For one, it's the way to find that color's complement. Second, it helps you to translate the colors that you see with paint.

EXAMPLE: See a tree in Autumn, classify it as an orange tree, then find an orange color on your palette.

REMEMBER: The painter deals with paint not with trees, or clouds, or water, etc., etc. etc..

CADMIUM ORANGE.

The most versatile source of bright orange. Cadmium Yellow Orange and Cadmium Yellow Deep are fun to have on the palette, but are disappointing as basic sources of bright orange. Even Cadmium Orange can be eliminated from an extremely limited palette because it can be made by mixing Cadmium Yellow Light and Cadmium Red Light. However, the color is common enough in nature to warrant having Cadmium Orange—its paint substitute—on your palette.

(NOTE: In all *Color Recipes* that call for a bright orange, Cadmium Orange is the one that's specified.) Mix it with Thalo Green to make muted, earthy greens, a useful mixture for flowers and for outdoor foliage backgrounds. Indispensable when painting bright yellow and orange flowers. A touch of it in flesh mixture for certain areas can add sparkle to a portrait.

BURNT SIENNA.

A semi-dark orange color that's very transparent and fast drying. This color is found on almost every painter's palette because it's the only source of dark, dull orange that's so commonly found in objects such as wood, crockery, dried grass, etc. Popularly known as rust. Mixed with any green, Burnt Sienna mutes the green and makes it warm. Mixed with Burnt Umber and black and white, it makes a natural brown that's suitable for tables in still life or dirt roads in landscapes. Used with any blue (Cobalt, Ultramarine, Thalo) plus a value of black and white, it makes a beautiful neutral gray. Warmer gray if more Burnt Sienna is used; cooler gray if more blue is used.

CAUTION: Burnt Sienna and white should *not* be used as a flesh mixture. It may be used with Viridian and gray in the *shadowed* areas of flesh, and, of course, in painting the many types of brown hair. Also, Burnt Sienna may be added to the flesh of dark-skinned people. We suggest that you check all the flesh mixtures in the portrait section of *Color Recipes* to realize the proper use of Burnt Sienna in mixing flesh.

FLESH.

An admixture that's made by almost all of the color manufacturers; it may vary in hue according to the formulation each company uses. Some of them may make Flesh more red than orange, some may make it duller than others, but all of them make Flesh by adding color into white. Flesh color, therefore, is as opaque as white. Since flesh colors have more zing if you mix colors into white as you need them, Flesh in a tube is only handy for large areas of flesh, such as in nudes. And then, Flesh should only be used as a puddle in which to *add other colors.* Strangely enough, it's a fine color to use as a lightening agent when painting flowers because it doesn't chalk up the color as much as white would. If you use Flesh instead of white to lighten your reds, you'll find that your reds won't turn violetish. *Use Flesh for painting copper.* A highlight made of Flesh plus Cadmium Red Light and Burnt Sienna provides a nice base on which to add an even lighter highlight of Cadmium Red Light and white. In landscape painting, Flesh can be used with white as light streaks in the sky and wherever sunlight makes an area very warm and very light.

Cadmium Orange Thalo Green

Cadmium Orange mixed with Thalo Green will give you muted, earthy greens.

Cadmium Yellow Light Cadmium Red Light

By mixing Cadmium Yellow Light and Cadmium Red Light, you can come up with a decent looking orange color. But why bother? Cadmium Orange from the tube is the most versatile source for bright orange.

Cool Colors

THE BLUES

THALO BLUE.

The darkest, most intense blue you can buy. *The most versatile.* It gets lighter and brighter with additions of white, and it never has to be darkened. You can dull it or mute it into shadow by adding Burnt Umber to any of the tones that have been made by additions of degrees of white. It's very transparent. If you want Thalo Blue lighter and brighter, add white. If you want tones of gray-blue, mix Ivory Black and white to a tone of gray and then "blue up" the gray with touches of Thalo Blue. Indispensable on a basic palette. I use only Thalo Blue on my palette because all the other blues can be made from it.

CAUTION: Thalo Blue is very strong. A little bit will do.

CLARIFICATION: Thalo is the proprietary name of M. Grumbacher. It has been shortened from the long, wind-blown, hard-to-spell pigment, "phthalocyanine." Winsor & Newton's version is Winsor Blue, Shiva's is Shiva Blue, and Liquitex chooses to call theirs, Phthalocyanine Blue. They're all derived from the same pigment. Although Grumbacher's Thalo Blue is mentioned in all *Color Recipes* the others named can be substituted.

PRUSSIAN BLUE.

Very much like Thalo Blue. Darker, slightly greener. Very intense, very transparent. Fell into disuse with the growing popularity of Thalo Blue.

ULTRAMARINE BLUE.

Also called Permanent Blue in some oil color lines. A blue that's tipped more toward violet than toward green. Not as dark in tone as Thalo Blue and definitely not as strong. Very transparent. Biggest use is in landscape painting. Mixes well with yellows for various shades of green. Mixed with Burnt Umber and white makes gray. Popular among students because they think of Ultramarine Blue as a "blue blue." Actually, it's a blue-violet, and it can't be used as a blue blue because there are many blues you can't mix if you have only Ultramarine Blue on your palette.

IMPORTANT OBSERVATION: Students veer toward the weaker colors and then wonder why their pictures aren't colorful. Ultramarine Blue is one of these weak colors. In fact, it's so weak you'll end up using four tubes of it to one tube of Thalo Blue.

COBALT BLUE.

A lighter, medium intensity blue. Rather strong and not as transparent as Thalo or Ultramarine. Its hue can be mixed by putting a little Thalo Blue into its value of gray. Cobalt Blue can be considered to be a dull blue. Remember — a blue that starts out dull can't get brighter.

CERULEAN BLUE.

A light opaque blue. A handy one to have on your palette along with Thalo Blue because it's much lighter than Thalo. However, you can mix Cerulean Blue by adding Thalo Blue to some white and then toning it down with Burnt Umber, then adding a mere touch of Thalo Green.

Ultramarine Blue mixed with White.

Thalo Blue mixed with White.

When white is added to Ultramarine Blue (also called Permanent Blue), its violet character is in evidence. Observe how clean and pure Thalo Blue tints out with white.

Cool Colors

THE GREENS

The complaint I hear most often about green is, "My greens don't look natural." Below are descriptions of the most popular greens available to artists; they will help solve this problem.

THALO GREEN.

The most versatile green because it's the darkest and most intense of the tubed greens. It's the basic green of my palette since nature's greens are all yellowish green. I always *dip into yellow first and add Thalo Green into the yellow.* When mixed into Cadmium Yellow Light, it makes light bright greens. It will make duller yellow greens if you mix Thalo Green with Yellow Ochre, Raw Sienna, Burnt Umber or Burnt Sienna.

VIRIDIAN.

In color, lighter and grayer than Thalo Green. With any of the yellows, Viridian makes grayer versions of the ones that Thalo Green and yellow make. From a standpoint of economy, it's cheaper to use Thalo Green than Viridian because a little Thalo Green goes a long way.

PERMANENT GREEN LIGHT.

A medium-toned green that needs yellow to make it more natural looking. I never use this color. The artist has white on his palette to lighten any color. It makes sense, then, to use the darkest colors rather than light ones.

CHROMIUM OXIDE GREEN.

A very opaque color and very strong in covering power. Mix with Burnt Umber, Burnt Sienna, Yellow Ochre, Cadmium Orange or Cadmium Yellows for lovely, natural looking greens. Since it covers so well, I use it whenever I go painting outdoors.

GREEN EARTH.

Although the colors look somewhat alike, Green Earth's characteristics are just the opposite of Chromium Oxide Green's. It's very transparent and very weak. Not at all suitable for landscape painting even though it's earthy looking. Green Earth is used mostly by the portrait painter who needs to make fragile changes in flesh mixtures.

Since this green covers so well, it makes a great color for landscape painting. Chromium Oxide Green is shown here mixed with white.

Green Earth is also know by its French name, *Terre Verde*. Many confuse this with Chromium Oxide Green, but Green Earth is very transparent and you can see by its tintout with white that it's extremely weak.

THALO YELLOW GREEN.

A very light bright yellow green. Its very light green tone balances the very darkness of Thalo Green. Mix it with Ivory Black for *background green.* And for fine flesh colors, mix it with Cadmium Red Light and white.

SAP GREEN.

A darker, more olive version of Thalo Yellow Green. This color is very close to nature's greens and good for landscape painting. Makes beautiful greens when mixed with light yellows. You're apt to use a lot of it because it's quite transparent.

NOTE: All the greens can look muted and more dimensional with a little red added to them. A touch of violet into all the yellowish greens can improve them.

A darker, more olive version of Thalo Yellow Green. It's quite transparent and makes beautiful green when mixed with light yellows, in this case, Cadmium Yellow Light.

THE VIOLETS

Violet's a very important color. Artists paint the effect of light and we're accustomed to seeing a warm light caused by the sun's rays. This warm light is represented by yellow. Where the light's *not* striking, then violet — yellow's complement — is essential to give the effect of shadowed areas. There are many violets available to the artist. Here are some of them with their characteristics.

CADMIUM RED MEDIUM.

A very reddish violet that's medium in tone and intensity. Very opaque pigment. This color in admixture with Ivory Black and white or with blue and white, makes interesting violets. *Don't ever use this color to paint things that you think of as red,* such as apples, red flowers, strawberries, etc. Cadmium Red Medium will disappoint you every time. Its strong violet nature isn't noticed when it comes from the tube, but once it meets up with white, it's definitely violet. All this information also applies to *Cadmium Red Deep.* Both these Cadmiums make dull, gray, bruised-looking violets.

THALO RED ROSE.

A red violet that's very intense and medium in tone. This is a very handy color to have on your palette, especially if you paint flowers. When mixed with white it blooms with great intensity. Don't squeeze this color out for a general palette of colors because it's not a very strong color. Of course, if you're a portrait painter, put a little out on your palette because the more little nuances of color you mix into your flesh the more chance you get to breathe life into your paint.

ALIZARIN CRIMSON.

A very dark reddish violet. It's transparent yet strong. If a palette of colors should be limited to only six colors of the spectrum, Alizarin Crimson should be the one to use for your violet. *Don't mistake it as a red.* Darken other reds with Alizarin Crimson, but don't use it alone as a red. Here's how to see for yourself how versatile Alizarin Crimson is as a violet: mix a light, medium and dark gray made of Ivory Black and white. Into each of these gray puddles, start adding bits of Alizarin Crimson. Notice the variety of violets that you get. Now, into these three puddles of reddish violets, add a touch of Thalo Green. The violets will grow cooler. These mixtures can be used to shadow any yellows.

Cool Colors

ROSE MADDER.

Same as Alizarin Crimson, only weaker.

THIO VIOLET.

Much the same as Thalo Red Rose, only bluer.

ULTRAMARINE RED.

A very weak, low intensity blue-violet. Should be used more as a gray than a violet to mute flesh tones that seem too raw.

COBALT VIOLET.

A bit more intense than Ultramarine Red.

MARS VIOLET.

Seemingly a red but really a low intensity reddish violet that's exposed when mixed with white. More often used with Ivory Black and white for reddish violet grays.

MANGANESE VIOLET.

A dark bluish violet that's transparent and not very strong. An excellent color to "shadowize" yellows. But it makes a rather drab color when mixed with white to represent violet objects.

Outside of flowers, you'll notice that there are very few violet objects in nature. So use your violet to "shadowize" yellow rather than as a mass tone color. Muted violets make excellent backgrounds for still lifes and portraits. Whenever your violet mixture seems too bright, tone it down with either Burnt Umber or Raw Umber.

REMEMBER: It's very hard to brighten a violet. It's bright as it comes out of the tube. Fragile additions of white will lighten and brighten; too much white will turn it gray. To paint a shadow on any violet object, darken your mixture with more violet and/or black and violet's complement, Burnt Umber.

Light Gray mixed with Alizarin Crimson.　　Medium Gray mixed with Alizarin Crimson.　　Dark Gray mixed with Alizarin Crimson.

Many people think of Alizarin Crimson as a red. It's not; it's really a violet, as seen clearly here in admixtures with light, medium and dark grays.

COLOR RECIPES FOR

Flowers

W hether we grow them, arrange them, give them or get them, paint them, or just own pictures of them, most of us like flowers. For my demonstration audiences, no matter where I have appeared, flowers were their favorite subject for me to paint. In my classes, students always look forward to their flower lessons.

When I decided to write *Color Mixing Recipes,* I gave long and serious thought to the kinds of flowers I would feature. I tried to include flowers known to most people and available in all or most of the country.

I realized, first of all, that I would have to explain the basic shapes of various flowers. (It's surprising how beginning painters won't look beyond the shape they see to find the basic geometric shape of the object). I then went on to set down the procedures, including some key brush maneuvers. Overall, I knew the problems my students had experienced with painting flowers would be the very same problems my readers would have. You will find, in recipe form just as in a cook book, the color mixtures you will need to get sensible looking flowers.

Follow my recipe directions carefully and your problems of painting the flowers in this book will be considerably eased. As a result, your painting of flowers will look more plausible. Furthermore, you'll be able to apply what you've learned in these lessons to other flowers as well. And pay special attention to the "Helpful Hints," easily identified by the picture of the paintbrush. Each one is a valuable guide that has come from my many years of study, analysis, practice and experience.

Chrysanthemums

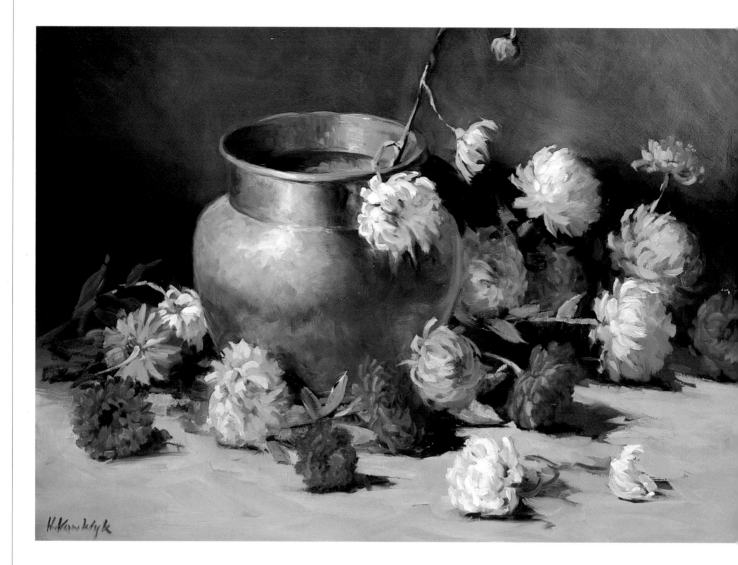

This recipe refers to one type of chrysanthemum, the one whose petal is *red at the top* and *gold at the bottom*.

STEP 1. Mass in the chrysanthemum shape with Light Red or Venetian Red mixed with Alizarin Crimson. *Keep this mixture more rusty than red.* Mass in just the bulk of the flower, not its straggly petals. And don't apply the mixture too thickly.

STEP 2. Now, with quite a bit of Yellow Ochre mixed into the basic tone of STEP 1, add a rhythm of strokes that indicates the petals of the flower. This mixture can also be used to add the straggly petals.

STEP 3. Some petals have their undersides turned toward the light. Use Yellow Ochre and white for these shapes. Apply the paint by loading the brush, pressing the paint on the canvas where the petal ends, and twisting the brush as you stroke toward the point where the petal is growing from the flower. This kind of stroke makes a little hook shape.

STEP 4. Where the yellow undersides are in shadow, mix Alizarin Crimson and a little Ivory Black or Cobalt Blue into Yellow Ochre. If you see any dark red areas, use Alizarin Crimson with a touch of Burnt Umber.

STEP 5. Where the light strikes the red part of the petals, use Venetian Red and a little bit of Cadmium Red Light.

Mass in solid
tone first . . .

. . . then add yellow
for the underpart
of the petals.

To make the petals look as though they turn,
actually **spin** your brush as you paint each petal.

Load your brush with paint for each petal.

Practice stroking light onto dark, as shown here.

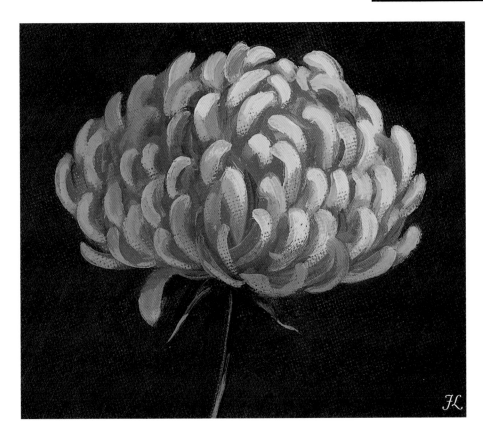

Even when painting a **mum** that's
one color, mass it in in a general
color and then add lighter tones
of that color and shadowed tones
of that color.

White Daisies

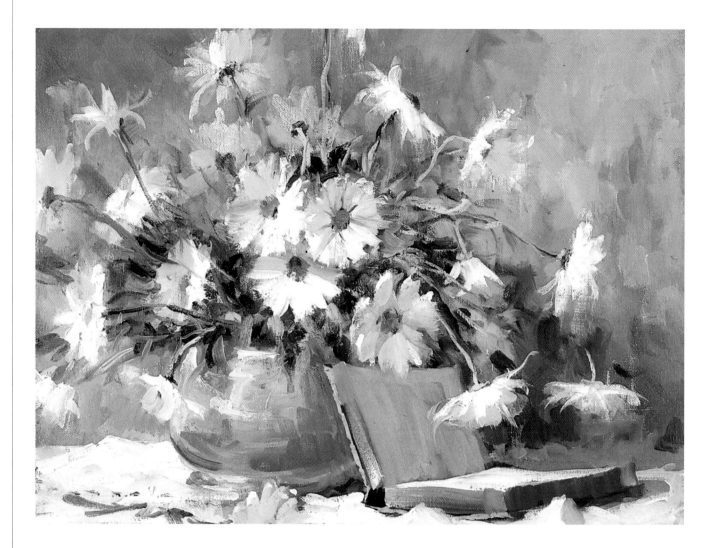

Any white object has to be painted first with a mixture of off white. "That," I jokingly say, "is white with a little *off* in it." Here, then, is the recipe for the "off" white daisies:

STEP 1. Mix a pale gray of Ivory Black, white, and Yellow Ochre to look much like dirty white curtains or that old "tattle-tale gray" (remember *that* color?). Use this mixture to mass in your flowers with no indication of petals or other details. Make sure your mass shape indicates daisies that are facing you (round) and those facing to the left, the right, and top (elliptical). If there are many daisies bunched together, mass in the entire silhouette of all of them.

STEP 2. Now you're ready to impart the *real* white of the daisies. It can only show up in contrast to the off-white it's being applied over. Mix a small bit (snit's a word I like to use) of Yellow Ochre into a lot of white. Load a brush with this mixture (a round bristle is excellent for this) and look for the petals that are lighter than the off-white mass tone. If the edge of the petal is coming toward you, start there and pull your brush into the button area (the center) of the flower. If the petal's going away from you, start at the button and let your stroke trail off as it reaches the end of the petal.

STEP 3. You may need some darks of Ivory Black, white, Alizarin Crimson and a little Yellow Ochre or Burnt Umber. To complete the flower, you'll need button color, leaves, and a green thumb.

Helpful Hint: Arrange your daisies in a way that you'll be able to see a few from the rear. They not only add variety to the arrangement, but they're also easier to paint.

Daisies are shallow little cones. Notice how the lighting affects these shapes in the many positions that daisies are found in a bouquet.

LIGHT SOURCE

Don't make all your daisies round — more of them should be elliptical.

JL

BASIC EXERCISES

A daisy's stem is perpendicular to the button. Paint stems in **two strokes** (indicated by arrows). This gives the flower a more airy look.

START STROKE
AND PRESS . . .
. . . THEN . . .
. . . PULL AWAY

Here are strokes to paint the petals. Always add the button last!!

Use your brush to give the **effect** of leaves rather than trying to record each leaf.

Daffodils

Mass in the silhouette of the flower in a mixture of Cadmium Yellow Medium and a little Yellow Ochre. Make sure this tone isn't so light you can't add more light without getting the color chalky (the condition of too much white added to color). Into this mixture add a little Ivory Black and Alizarin Crimson for the *body* shadows. You could also use Manganese Violet instead of the Alizarin Crimson.

With a clean brush, mix a new puddle of Cadmium Yellow Light and some white to accentuate the illuminated areas of the flower. Reflections in the shadows can be Cadmium Yellow Medium. For the paler type of daffodils, such as narcissus — add a little more white to each mixture.

IMPORTANT: In painting flowers, the mass tone should always record the particular shape or silhouette of the flower.

 Helpful Hint: For any yellow flower, it's best to have the following yellows on your palette: Lemon Yellow, Cadmium Yellow Light, Cadmium Yellow Medium, Cadmium Yellow Orange, and Yellow Ochre.

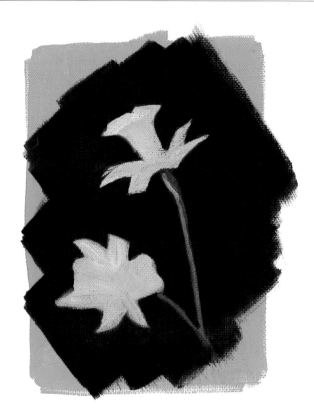

The mass tone of daffodils. When painting flowers — or *anything.* for that matter — it's far easier to add the lights to the mass tone first and then accent with the darks.

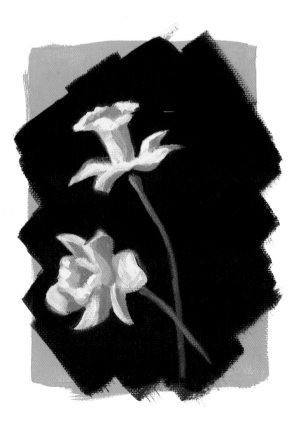

The light areas have been added.

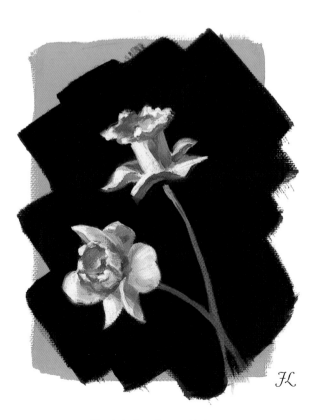

The darks have been added.

Flower Foliage

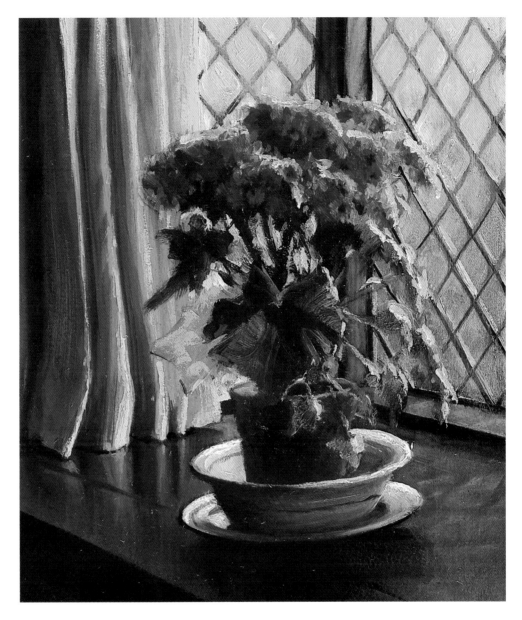

I photographed this flowering plant in the house where William Shakespeare was born in Stratford-on-Avon, some 90 miles northwest of London. I was intrigued by the leaded windows and drapery which functioned so well as the setting for the placement of the plant. It became a perfect example of flower foliage. I'd like to point out here that everything around an artist can be the subject for a painting. You just have to develop an eye for workable compositions, even if they appear to be mundane.

The reason foliage is difficult to paint is that there's no green near it in color that's found in a tube. Many think Green Earth is the answer. Not so — it doesn't cover. Some think Chromium Oxide Green is the answer. Not so — it's too light and too blue.

Since greenery in most flower arrangements is very much shadowed by the flowers, the mass tone mixture for the green area should be darker than you would think. Thalo Green, with an addition of Yellow Ochre and Burnt Umber, will give you a dark yellowish green. Use this mixture as a mass tone. And where you see the foliage very dark, add some more Thalo Green and a little Alizarin Crimson to deepen the mixture.

NOW, LET'S ADD SOME LIFE TO THE GREENERY:
You'll need a light yellowish green. Mix it by taking a gob of Cadmium Orange and a touch of Thalo Green. If this doesn't seem bright enough, add some Cadmium Yellow Light and white.

STEP 1. The danger in adding the lights to greenery is to use Cadmium Yellow Light or Medium and in so doing impart a brassy look to the foliage.

STEP 2. The very lightest yellow greens you see can be found in a tube. It's called Thalo Yellow Green (or other yellow greens by other manufacturers). But, you'll find, this tubed color will need some white.

A Flower Picture's Background

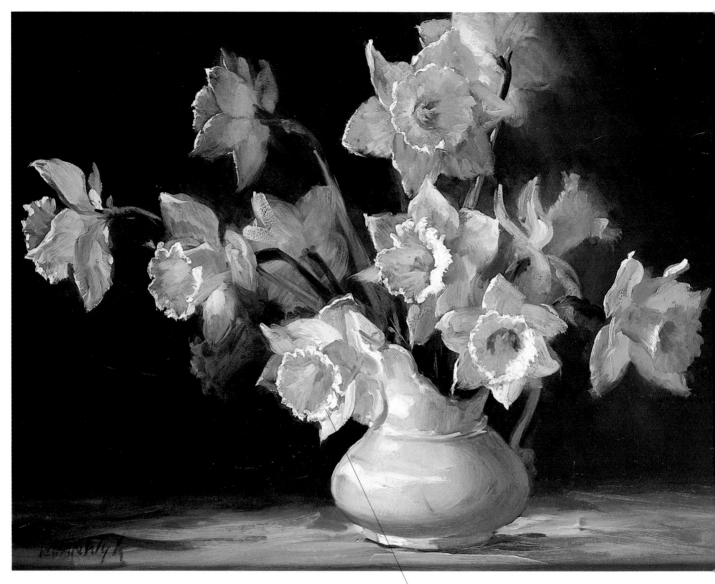

Do you want your flower color to look light?
Use a very dark background.

I've said it before in reference to still life; I'll say it again in reference to flowers:

Dark Subject, Light Background!
Light Subject, Dark Background!

Of course, this doesn't mean the absolute extreme in value. But deciding whether the subject's going to be darker or lighter than the background is an initial decision when painting flowers. An American Beauty rose against black

becomes a light-toned flower. But against white, the red of the flower appears extremely dark.

In my studio I have three backdrops: *one white, one neutral gray, and one black.* When I'm intrigued with a flower arrangement, I slip each of these backdrops behind the flowers and judge which one shows the flowers off to their greatest advantage. Once this decision's made, I feel I'm halfway home, because the *tone of the color* is more important than the color itself.

Now for the color of backgrounds for flowers: Since flowers are beautiful in color, and usually quite dramatic, a neutralized colored background is the contrast they need. A painter can never go wrong using nature's secrets. Nature's backdrops for flowers are grayed yellow greens, soft browns, and neutral grays that are quite light or quite dark.

The tone of your background for your flowers will be determined by what tone of gray on the VALUE SCALE (using black and white) you mix these colors into. A combination of colors can be added to any tone you've chosen, whether it's light, #2, or dark, #8.

Here are some suggested background colors to mix into the tone of gray that you've chosen:

1. Thalo Yellow Green and Burnt Umber for orange mums, yellow or white daisies, or daffodils.

2. Burnt Sienna, Thalo Green, and some Cadmium Orange for almost any flower.

3. Manganese Violet, Burnt Umber to make a neutral gray background for almost any flower.

4. For interesting dark backgrounds, use Indian Red and Ivory Black or Burnt Umber and Thalo Blue into dark gray (#8 on the VALUE SCALE).

REMEMBER: a natural looking flower picture *has to have a background of nature's color*. As soon as you use bright colors such as turquoise, obvious purples, brilliant pinks, and others, your painting becomes decorative instead of being a picture of nature's flowers. It's up to you!!

NUMBER 1

A background for orange mums, daffodils, or yellow or white daisies is made by mixing Thalo Yellow Green and Burnt Umber.

NUMBER 2

A mixture of Burnt Sienna, Thalo Green and some Cadmium Orange will provide a background for almost any flower.

NUMBER 3

A neutral gray made of Manganese Violet and Burnt Umber will house any flower you choose to paint.

NUMBER 4

Indian Red and Ivory Black will deliver an interesting dark background.

Do you want your bouquet to be a dark silhouette?
Use a light background.

Flower Stems in a Clear Vase

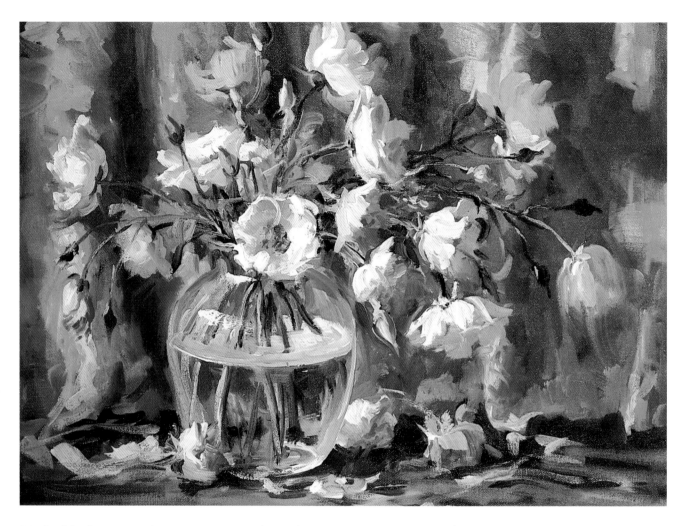

Much of the fascination of painting a picture is due to the air of danger, jeopardy, and suspense about the process. The process for painting stems in a clear glass is a perfect example, because the last step, or application of paint, can wreck all the preceding steps beyond repair. The only recourse, then, would be to wipe out and start over from the very beginning.

STEP 1. Paint your background color over the area where the glass or vase will be.

STEP 2. With Yellow Ochre and a little Thalo Green and some little Burnt Umber, paint in the green leaves and stems that you see in the glass.

STEP 3. With a brighter green made of Cadmium Yellow Light or Thalo Yellow Green mixed into the mixture of Step 2, load your brush and paint in the lighter stems. Make sure these stems have some bearing on the placement of your flowers. *Paint them as though there was no water in the vase.* You should now have the stems, the bouquet and the background with no indication of glass.

STEP 4. With Ivory Black and white mixed into the green of Step 2 to make a light gray, paint in the ellipse of the flat plane of the water. This color should cover or obliterate the stems and leaves where the elliptical shape of the top plane of the water shows. This shape has to be more realized than seen.

STEP 5. Now, with your stem color, paint the stems down into the gray elliptical shape in the places where the stems look like they're going into the water.

STEP 6. Into the gray of the ellipse, add some more white and a touch of Alizarin Crimson, and paint the lighter gray that you see on the edge of the glass that makes the vase's form. Add any lighter and darker reflections that seem to form the vase's shape.

STEP 7. Finally, take white and a breath of Yellow Ochre. Load the brush and strike highlights on to show the front surface of the glass. Especially have a highlight flash *over the area* where the stems go into the water. This will make the water and the stems appear to be in the glass.

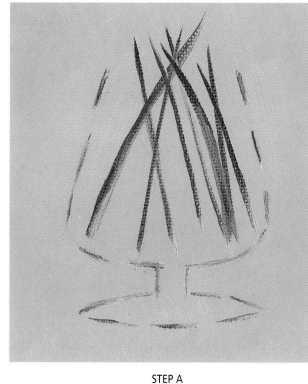

STEP A

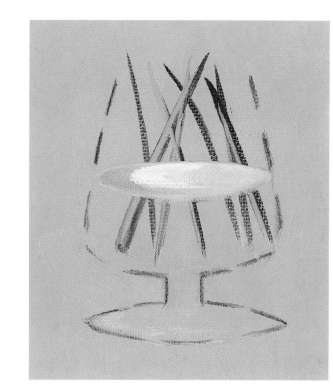

STEP B

The dotted outlines in "A" and "B" are there to show you that you know where the vase is. You've only barely indicated it on your canvas, however, by stroking the vase's shape in with the background color.

STEP B Paint in water ellipse.

STEP C Bring stems back into water in different places, then paint the glass around the water and the stems.

Helpful Hint: It is important that you never put a highlight down the center of anything. It divides the object monotonously in half.

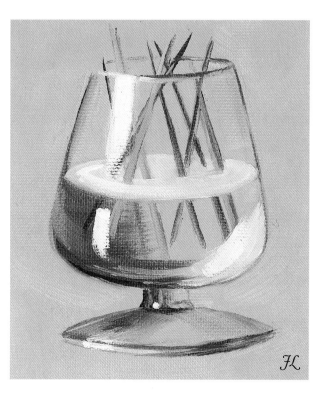

STEP C

Geraniums

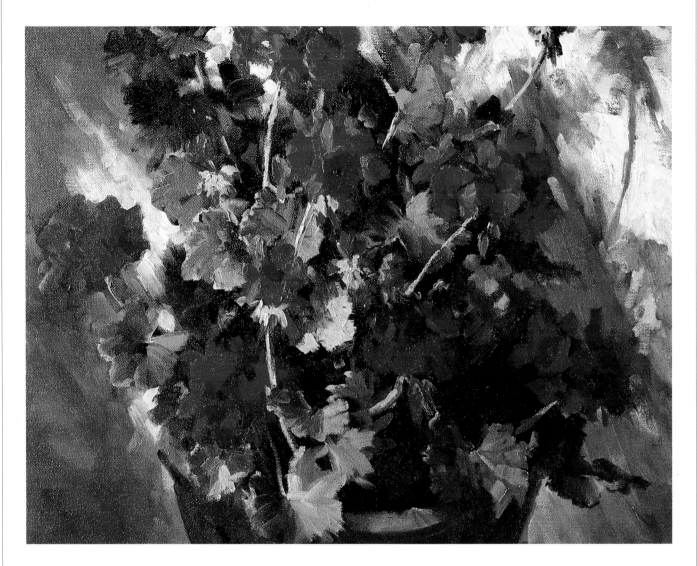

These hardy, colorful flowers are exciting to paint. The leaves, you'll find, are more difficult to do than the blossoms.

FIRST, LET'S DO THE FLOWERS:

Here are the reds you'll need to record them: Alizarin Crimson, Grumbacher Red, Cadmium Red Light, Thalo Red Rose.

STEP 1. *Mass in the blossom* with Alizarin Crimson and Grumbacher Red.

STEP 2. Add lights of Grumbacher Red and white.

STEP 3. Go even lighter — Grumbacher Red, Cadmium Red Light, and white.

STEP 4. Add a little Chromium Oxide Green to the mixture in STEP 1, and use for the shadows. For the darkest darks, use pure Alizarin Crimson.

NOW, LET'S DO THE LEAVES:

STEP 5. *Mass in the leaves* with Chromium Oxide Green and Yellow Ochre.

STEP 6. Paint darker leaves by adding Thalo Green and Burnt Umber to the mixture in STEP 5.

STEP 7. Shadows on the green leaves: add Alizarin Crimson and Ivory Black to the mixture in STEP 6.

STEP 8. Brighten and lighten the leaves by adding Thalo Yellow Green and some white to the mixture in STEP 5.

STEP 9. If you see any degree of gray on the leaves, mix Ivory Black, white, and Alizarin Crimson, and apply on top of the already green-painted leaves.

Violet Lilacs

Let me warn you, lilacs of any color are hard to paint. Violet ones are double trouble because violet is one of the hardest colors to paint. The trick is to make a hard job easy. So try this painting challenge only on *a very, very light background* or on *a very, very dark background.*

On a *light background* you can get the vividness of violet by using violet mixtures that are dark in contrast to the background. These dark violet colors are much like the violets available in tubes.

Using a *dark background* will stop you from having to lighten your violet colors to the degree that you'll reach a chalky stage. The whole secret to success in painting with violet is in the background tone you work against.

Tubed colors you'll need: Thalo Red Rose, Phthalo Cerulean Blue, Alizarin Crimson, Thio Violet, and Cobalt Violet. Since flowers are in the area where we see color "extraordinaire," the flower painter needs scads of color.

Your bunches of lilacs will look raw in color and flat in dimension if you don't impart some of violet's complementary color to your tonal variations, especially in the mass tones and in the shadows. For instance, add shadows on the bunches by adding more of the pure violet color and Burnt Umber (complement to violet).

Now, add lighter values where the light strikes the bunches with a mixture of Thalo Red Rose and white. Adjust this color with a blue, according to the lilacs you're using as models.

As a mass tone, use a slightly toned down violet by mixing some Burnt Umber or Raw Umber or Ivory Black into your violet mass tone. You may find that a touch of Viridian will gray down violet as well as the colors just mentioned.

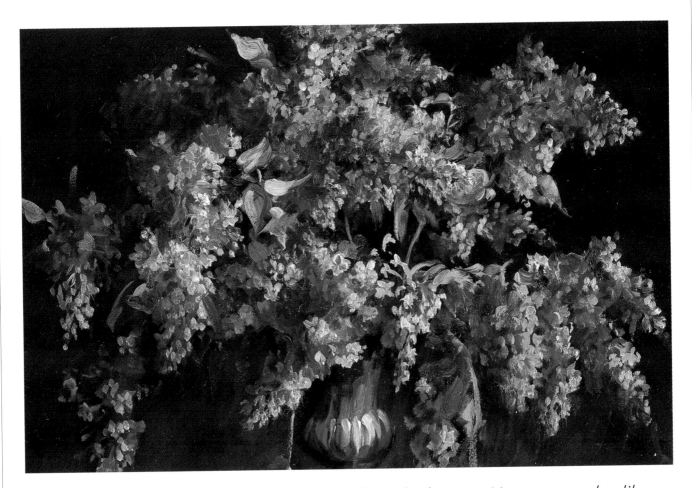

Whenever you paint a flower that has a repetitious pattern, such as lilacs,
don't fall into the habit of painting one just like the other.
Avoid this by varying the silhouettes and recording the peculiarity of each spire.

Petunias

Against a light background, these colors aren't too difficult to represent. It seems more practical to put the light background in first, slopping the background color into your petunia's outline. The more dominant petunia color can later be chiseled back over the background color.

The mass tone color is very important; it should be *clean, vibrant,* and *strong.*

For **Red petunias,** mix Alizarin Crimson and Grumbacher Red. Or Grumbacher Red and Thalo Red Rose. Or Alizarin Crimson with a touch of Cadmium Red Light.

CAUTION: Don't use Cadmium Red Medium or Cadmium Red Deep. *They'll make a dull flower.*

Pink petunias. Use the same mixtures as for red but add a little white and go lighter on the Alizarin Crimson.

Purple petunias. The basic tone could be Alizarin Crimson with a touch of Thalo Blue. Or Thio Violet with Ultramarine Blue. Or Ultramarine Red and Alizarin Crimson.

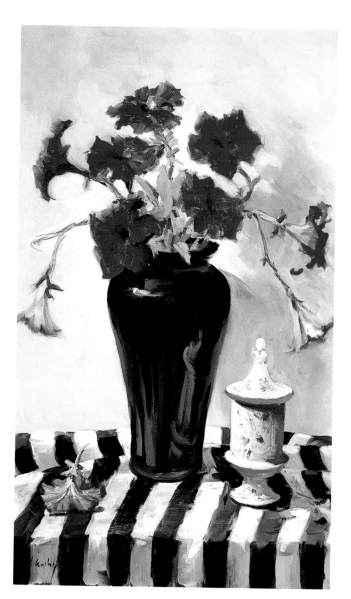

Now to make these silhouettes look dimensional. The red and pink petunias are comparatively easy. In the *red,* use pure Grumbacher Red and add lighter areas that you see. In the *pink,* add white and Grumbacher Red.

The purple petunia doesn't get a brighter spot. It seems to have lighter, grayed areas that make it look very velvety. Use Ivory Black and white, Thalo Blue, Alizarin Crimson, and Burnt Umber to make a muted gray-violet. And use this mixture for the interesting patterns of lighter areas on the petunias.

To *shadow* the three petunia colors: **The Red** - Grumbacher Red, Alizarin Crimson, and add a little bit of Thalo Green. **The Pink** - Add more Alizarin Crimson and Grumbacher Red to the basic tone and add a little Viridian. **The Purple** - Make a new mixture of Alizarin Crimson, a little Thalo Blue, and some Burnt Umber.

Poppies

Helpful Hint:

When painting any tubular-stemmed flower – like poppies, zinnias, tulips, etc. – submerge the stem in water up to the base of the flower for 30 minutes to fill the stem with water. Then arrange your flowers and don't start painting them until about an hour later. This will give them a chance to settle, and they won't move while you're painting them.

The beautiful characteristic of poppies is the *paper thinness and little accordion-like ridges* of the petals. In order to get the *thinness,* pay close attention to the reflections which are mostly dependent upon your background color. To paint the "accordion pleats," use a #14 red sable or sabeline Bright brush (or a size 8 *Helen Van Wyk Overture*), that has been loaded with a lighter color than the mass tone, and pile little lines of light paint onto the petals. It's impossible to create this fragile effect by *adding dark lines.*

NOW, DOWN TO BUSINESS:

STEP 1. Mass in the flower shape in a general tone of Grumbacher Red, a touch of Cadmium Red Light, a breath of white, and a bare whisper of Chromium Oxide Green. Don't start this application on the outline of the flower; make your stroke start from the *interior of the shape and stroke outward* toward the flower's periphery.

STEP 2. Now, with a mixture of Grumbacher Red, Cadmium Red Light, and more white than you used in

STEP 1, add the lights that you see on each petal, starting with the petal that's farthest back from your point of view. Have a brush handy with the basic tone to repaint the petals that are in front of the one you've just added lights to. This will make the petals look like they overlap. Repeating this process, the last petal you paint should be the one that's closest to your view.

STEP 3. Accentuate your flower with some darks of Alizarin Crimson. A large, round red sable brush (approximately #8 – #12, or my *Finale*) is great for this process.

STEP 4. For the pinker type poppies, use more white in each mixture. For poppies that have that beautiful shrimp or salmon color, add Cadmium Orange in quite a glob to each of the suggested mixtures.

STEP 5. *For that important reflected color:* either pure Cadmium Red Light, or Grumbacher Red and Cadmium Orange, or Grumbacher Red and white. You have to gear this color's tone to be darker than your lighter values, but lighter than your mass tone.

Roses

Most students have trouble with this subject because they try to translate with their paints the beautiful dewy look of a red rose too soon. You must first paint the red rose and then impart the dewy look to it.

STEP 1. Mass in the silhouette shape of the rose a little smaller than you really want it to be when it's finished. Use a goodly amount of Alizarin Crimson pepped up with a little bit of Grumbacher Red.

STEP 2. Take some white and mix into it a lot of Grumbacher Red. Don't make a small puddle because you're going to have to pile this lighter tone onto the already wet massed-in red flower. Each petal that seems lighter has to be painted with a fresh brushload of paint.

STEP 3. Add a few darker tones of Alizarin Crimson with a breath of Thalo Green.

NOW FOR THE *DEWY-LOOK:*

Mix Ivory Black and white into a gray that's a little lighter in value than the mixture in STEP 2. Saturate a big soft brush (about 1" wide) with this gray, then wipe the brush with a rag so you can then lightly stroke a breath of gray over the flower's petals. If you don't wipe your brush with the rag you'll end up shocking the flower with the gray instead of injecting a hazy, dewy look to it.

Adding the dewy look is more successfully done when the painted rose has been left to dry a bit, like overnight.

Helpful Hint:

If your paint gets too thick, take a clean rag, lay it carefully over your painting, run the heel of you hand over the rag, then lift the rag and VOILA! — the flower shape remains but the paint is no longer unhandy to work on.

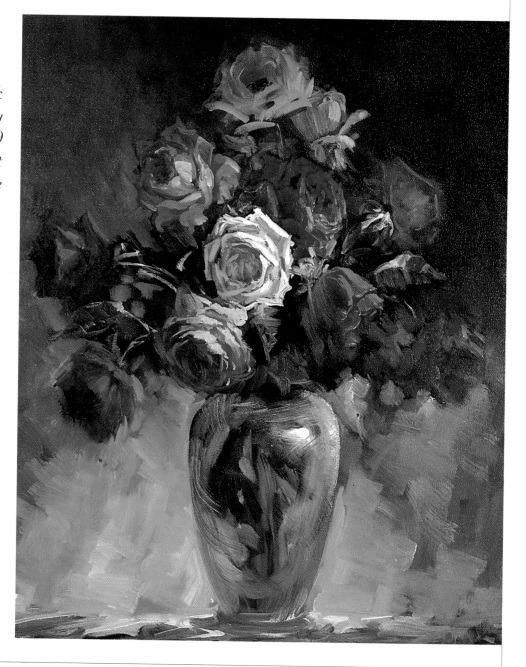

Orange Zinnias

STEP 1. Mass in the silhouette of the flower with Burnt Sienna. Don't apply this color too thickly. And when you apply it, I just know you're going to shriek: "It's too dark!" It's not, *because in the end it's going to be your shadows.*

STEP 2. Mix Cadmium Yellow Light and Cadmium Red Light and start forming the petals of the zinnia.

STEP 3. Now, use Cadmium Orange with a little bit of white and accentuate the petals with this lighter tone.

STEP 4. Paint the colors of the center, and the shadow caused by the fullness of the center, by using a touch of Thalo Blue into Burnt Sienna. You can also use this mixture to accentuate some of the shadow.

When you paint multiple petaled flowers like zinnias, it seems easier to paint the half-hidden petals first, gradually overlapping them as the petals come more toward your point of vision. You end up by painting the completely visible ones last. Also, since you're working from dark to light, you'll have to load and reload your brush with color for each petal.

Helpful Hint: When you paint flowers use a large container of turpentine or odorless paint thinner to clean your brushes between mixtures. *Every mixture that's used to make a flower should be a fresh mixture.*

White Tulips

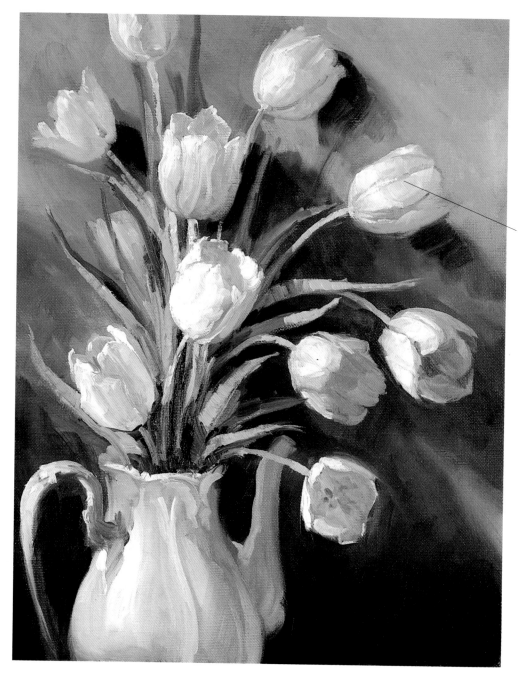

Notice carefully how each tulip petal has a spine in the middle. The addition of your lighter and darker tones to your mass tone should try to record this important feature of the tulip's anatomy. Many times you can't paint the effects you see because you don't look for the important characteristics.

REMEMBER: if you can see it you can paint it!!

The side view of tulips is easy compared to the front view that makes one look into the bowl of the tulip. The common mistake in painting this difficult view is to paint the lighter yellow color, that's seen in the bowl, too light, making the tulip look flat rather than dimensional. For that lighter yellow, use Raw Sienna, which will keep that yellow in its place. And when painting that view, paint the Raw Sienna color in first.

The white of the tulip: Black and white with a little Yellow Ochre for a mass tone.

For the lighter white: White with a touch of Thalo Blue.

For the darker white: A little Burnt Umber into a darkish gray of Black and white.

Helpful Hint: When you paint flowers made up of two colors, always paint the more delicate color first since the more powerful color will surely overtake it.

Landscapes

I am not a landscape painter. This doesn't mean, however, that I don't know the elements and the rules, I guess you can say, of landscape painting. Just like other kinds of painting, you have to carry some degree of common sense to your easel. When painting flowers, for example, you have to be aware of the relatively short life span of flowers and approach the painting with this in mind. You then paint the flowers first.

The subject we will deal with in this section is landscape painting. What is a landscape? A good rule of thumb is to say that anything that you paint out-of-doors can be classified as a landscape. It can be a painting of the sea, a pasture, a forest of trees, mountains, houses, details of houses or even a city scene. Landscape painting covers a wide range of environments.

An important caution about landscape painting is to be aware of the changing light. Whenever I would go on location to paint, I'd either go in the early morning hours or late afternoon. I never painted at high noon when the sun is directly overhead; I don't know of any of my colleagues who would.

As for canvas size, I've never tried one larger than 20 x 24 (even *that's* too large for me); I usually saved the larger sizes to do in my studio from sketches I'd made at the scene or from photographs that I'd taken. Most landscape painters work this way. No one could possibly believe that the three great American landscape painters of the nineteenth century, Albert Bierstadt, Frederick Church and Thomas Cole, whose monstrously large paintings grace the walls of many major museums, ever painted their ultra-large pictures while on location. They made scads of sketches in both charcoal and oil colors at the scene and then went to town on them in the comfort of their studios.

My palette of colors for landscapes is the same as I use for all of my painting, except for a few changes. The chief one is changing my white from Zinc to Titanium (a better covering white) and the addition of Chromium Oxide Green, an opaque green that I find very handy to have for outdoors. The rest of my palette is explained in greater detail in the *Color Recipes* that follow.

Basic Brush Work

The big mistake the student painter makes is thinking he can get the effect in one application. Paint can be made to look like oceans and reflections, but you have to invest the paint on the canvas first before you can realize the dividends that the paint can offer you.

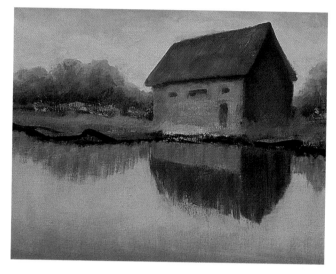

STEP 1

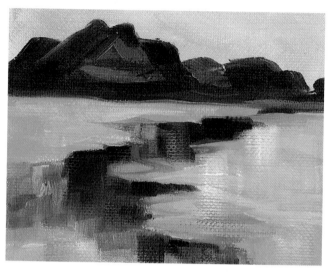

STEP 1

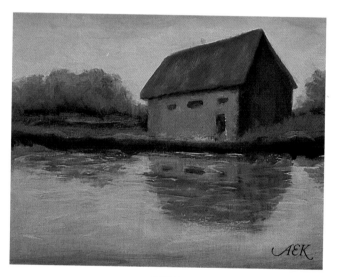

STEP 2

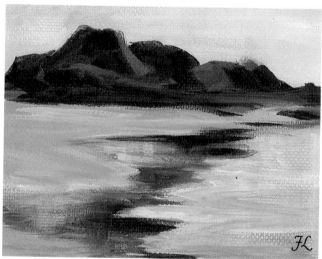

STEP 2

REFLECTION IN STILL WATER

STEP 1. Paint all the values in the water in vertical strokes. Don't put any more detail in than shown here.

STEP 2. Now, wiggle the contrasting tones together to give a feeling of ripples, and smooth out the entire application. If you stroke into the edges of your subject, they can be sharpened again at the end.

WET SAND

The problem here is to paint wet and dry sand on the same plane

STEP 1. Paint the two types of sand in different ways: horizontal strokes for dry; vertical ones for wet.

STEP 2. Unify the two by lightly brushing them in horizontal direction. Use a large, soft dry brush for this.

Autumn Colors

Autumn's spectacular color is tempting to paint. So often it's incorrectly painted too brightly. The beauty of Autumn's colors is the way the sun strikes them. *These sunlit colors have to be added to an already painted tree of a darker color.*

If you want the sun to shine on an orange tree, you have to mass the tree in with a gray (Ivory Black and white) and Burnt Sienna so that your Cadmium Orange and white can be used for the areas where the sunlight hits.

If you want the sun to hit a yellow tree, mass the tree with a toned-down yellow: gray (Ivory Black and white) with Raw Sienna and Cadmium Yellow Medium in it so that Cadmium Yellow Medium and white can be used for sunlight.

So often *the red trees* in Autumn are mistakenly painted with Alizarin Crimson. A mixture of Alizarin Crimson and Venetian or Indian Red would be a better mass tone. For the sunlit area, use Grumbacher Red, Cadmium Orange, and a little white.

Alizarin Crimson and Venetian Red provide the tree's mass tone; for the sunlight: Grumbacher Red, Cadmium Orange and a little white.

A tree tone of gray (black and white) with Raw Sienna and Cadmium Yellow Medium is sunlit with Cadmium Yellow Light and White.

AUTUMN PALETTE

Cadmium Orange and white mixture is shown in conjunction with a tree of gray (black and white) and Burnt Sienna.

Gray Barns

I think gray barns are beautiful. I've seen them in Ohio, Iowa, Kansas, and other Midwestern and Western states. It's amazing how colorful they can be:

In the *early morning* when the gray seems more *orange*. In *mid-day* when the gray is a surprisingly *cool gray yellowish green*. And at *dusk* when the gray is *reddish or quite violet*. I particularly love gray barns on bleak days when their colors are very subtle.

No matter what time of day you want to paint gray barns, here's a good rule to follow: Where the light *strikes* the barn the *gray is warm;* where the light *can't strike,* the *gray is cool.*

In value, the stronger the light, the stronger the contrast of value between the light warm. and the darker cool. This contrast diminishes to an almost sameness of value as the light diminishes the bleakness of a cloudy day.

VERY IMPORTANT: When mixing a *warm gray,* add a little *cool color,* such as Manganese Violet. When mixing a *cool gray,* mix in a little *warm color,* such as Thalo Yellow Green. Doing this will give your grays a glow.

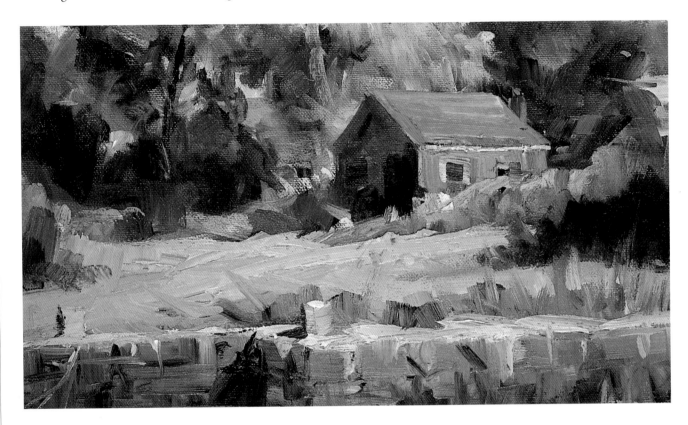

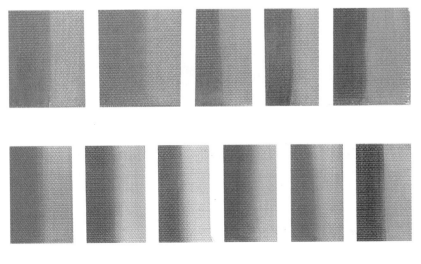

MIXTURES FOR WARM GRAYS: Add into Ivory Black and white any one of these colors *(left to right):* Cadmium Red Light, Raw Sienna, Burnt Umber, Raw Umber, or Burnt Sienna.

MIXTURES FOR COOL GRAYS: Add into a darker gray made of Ivory Black and white any one of these colors *(left to right):* Cadmium Yellow Light, Viridian, Cerulean Blue, Alizarin Crimson, Chromium Oxide Green, or Manganese Violet.

Red Brick

Painting bricks, as with so many other subjects in this book, relies so heavily on the procedure, use and the common sense that you apply to painting this material. First, paint the entire wall to be "bricked" the color of the mortar, brush in your brick color, starting at the top and working your way down, leaving the mortar to show between the bricks.

The basic color of the most common brick is: Venetian Red, a little Yellow Ochre, and a little white. The colors of bricks vary slightly, and into this basic color you can add Burnt Umber for the darker ones, a little Alizarin Crimson for the redder ones, and saturate the basic mixture with gray #2 on the VALUE SCALE for the more antique type of brick.

The mortar between the bricks is a warm gray (Ivory Black and white to gray #2 on the VALUE SCALE with a little Yellow Ochre added).

As an example of what to do with red brick, let's paint a brick wall. The problem here is not to have the brick color mush with the mortar color in such a way that will cause the construction of the wall to lose its definition. There's also the problem, at the other extreme, of making the mortar and bricks too obvious.

It's preferred, and easier, to paint the *entire wall first in the mortar color.* Then, with a brush that's the *width of the bricks'* width, and loaded with brick color, paint the bricks in one row across. Do the top row first and make *each stroke* the *length of the brick* you're painting. Now, do the row under it, remembering that the bricks *don't* line up one under the other but are placed so that the vertical mortar line of the row above falls in the *middle* of the bricks in the row above. The third row, therefore, will be a repeat of the first, and the fourth row will be like the second, and so on.

If you want your brick walls to look *obvious,* paint the brick color over *dried or slightly dried* mortar color. If you want your brick walls to be more *muted,* and less obvious, paint the colors *wet-into-wet.*

To get the *rough texture* of the bricks, drag a *lighter version* of your brick color (by adding white) over the already painted version of your brick. In this way, the brick is painted with *two tones,* showing a feeling of the pitted texture.

Dirt Road Through the Woods

Sometimes it's not only the color that presents a problem in painting objects. Dirt roads are a good example. If you apply the correct color in the wrong manner, instead of getting the look of a dirt road, the paint will just sit on the canvas doing nothing.

The major problem about painting roads is to make the roads lay flat. This can be done by applying the color in horizontal strokes rather than in strokes that follow the direction of the road. Naturally, this applies to a road that goes *into* the picture, vanishing into the woods.

BASIC DIRT ROAD COLORS:

Ivory Black and white to make a quite light gray, into which add Burnt Umber and Burnt Sienna (more Burnt Umber). Or use Burnt Umber and white and some Yellow Ochre.

Rid yourself of the preconceived idea that the road is brown. Whatever kind of color the road is make sure the color is *lighter in the distance* and *darker in the foreground.* This lightening in the distance is done with light gray (Ivory Black into a lot of white). A pale violet gray (Alizarin Crimson, Ultramarine Blue, and white) would also do beautifully.

The darkening in the foreground is often mistakenly done with more of the road color. *No! It should be done with a darker gray:* Alizarin Crimson and Ultramarine Blue mixed into your road color.

So often a road through the woods has *shadows of trees* falling on it. Make sure these shadow patterns pay respect to the contour of the road. If the road is crowned, the shadows will have a semi-arced shape. If the road has ruts, the shadows are a good way to show these by having them fall down into and then out of the ruts. These shadows are usually violet: Alizarin Crimson and Ultramarine Blue into road color. The shadows are also lighter in the distance than in the foreground.

Helpful Hint: Make sure your basic road color isn't raw looking. The rawness is eliminated with the gray. And, strangely enough the basic tone of the road isn't that much different from the tone of the grass or weeds alongside it. **It's a different color, not a different value.**

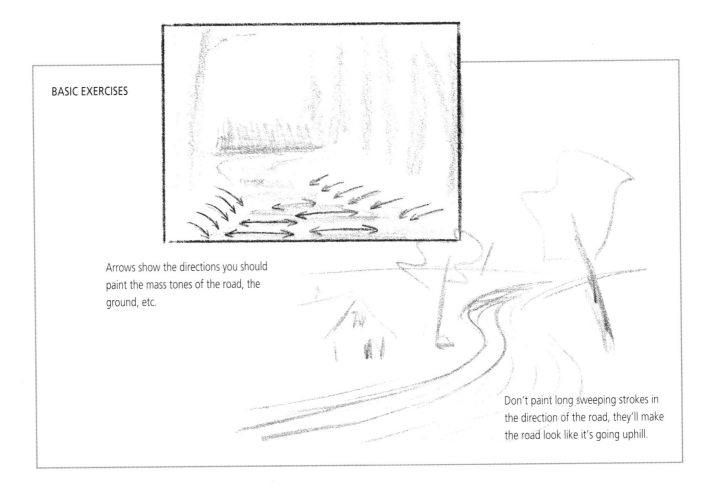

BASIC EXERCISES

Arrows show the directions you should paint the mass tones of the road, the ground, etc.

Don't paint long sweeping strokes in the direction of the road, they'll make the road look like it's going uphill.

Your shadows should follow the contours of the road.

Add all sparkles of sunlight last.

For sunlight that may be flashing across the road in spots, use Yellow Ochre and Cadmium Orange into white.

Docks in Harbors

The most common mistake that I've seen in paintings of docks is that the docks are too sharply delineated. This may be due to the fact that the artist painted the water *around* the docks. If this is done, the docks take on a *pasted-on look.* Well, here's how to avoid this mistake: make sure you paint in all your water areas, overlapping them *into* all of the drawing of the docks. And while the paint that represents the water is *still wet,* paint the darker tone of the docks in on top of the wet water tone.

Where the dark meets the light, *the edge will fuse.* You can sharpen some of these edges, especially the pilings and the part of the dock that's closest to you, leaving the outline of the dock that's farthest away a mere muted edge.

Docks are usually a warm gray made of Ivory Black, white, and Burnt Sienna; or black and white and Burnt Umber.

The *shadows* on the docks are violetish. Add Thalo Blue and Alizarin Crimson to the mixture, or put this mixture on straight.

When the light strikes the tops of the pilings, represent this with gray, made with Ivory Black and white.

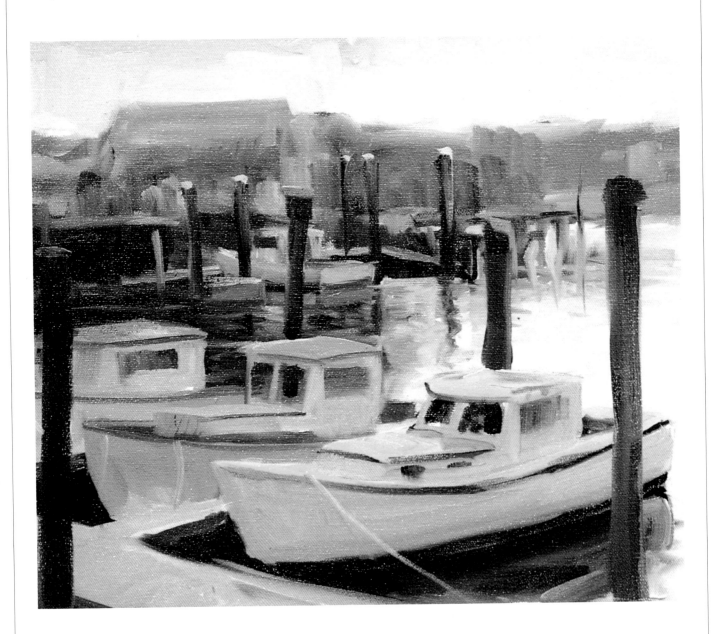

Fences

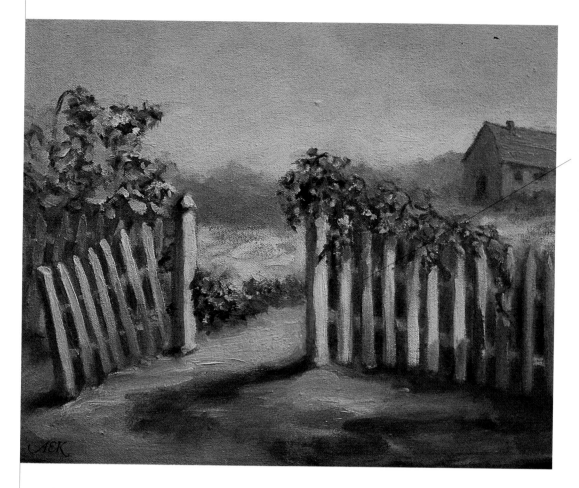

Fence Posts will have more dimension if you paint them in two strokes — one stroke of **dark,** one stroke of **light.**

Throughout the country, you'll find all kinds of fences — stones and rocks, barbed wire, natural wood, white picket, etc. Fences are great elements to put into a landscape.

A GENERAL RULE:

Add the fence on top of an already painted area. The main thing — the ground has to lay flat; the fence has to stand up.

Sometimes barbed wire and fences in the background can be scratched into the wet paint. Many fences are more easily applied with a palette knife, since a knife can pile wet paint onto wet paint more easily than a brush can, especially if the fence is lighter than the area that it's being painted over.

When painting *picket fences,* don't paint every picket. If they're close together, mass in the entire area with a gray (black and white) and add lighter tones to this in vertical strokes that suggest all the pickets.

REMEMBER: IF YOU "PICKET" IT WON'T HEAL!!

To paint your fences in proper perspective, always measure and compare the height of the fence post closest to you in relation to the fence that's farthest away from you. Perspective plays funny tricks with the size of objects. A fence post in the foreground, for instance, can appear to be bigger than a silo in the distance.

HERE'S A GOOD TRICK TO MAKE A FENCE STICK UP:

Observe the fence's cast shadow on the ground and paint the cast shadow boldly.

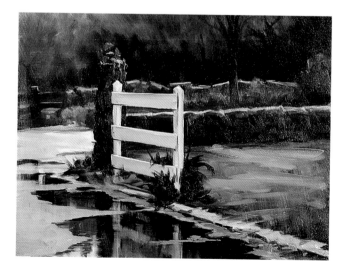

Fog

Fog diminishes objects we see as they're farther away from our sight. To translate fog with paint, mix a warm gray: white, a little Ivory Black, Burnt Sienna, and then some Cerulean Blue. This gray should look like the color that's known as "pearl" gray.

STEP 1. Mix a sizable amount of this *"fog color"* and make a mound of it on your palette.

STEP 2. Now, when you mix the colors of the subjects in the *distance,* add a lot of "fog color."

STEP 3. As you paint in the elements of your composition, always add some of this gray to each color mixture, using *less and less* of it as you work toward the foreground.

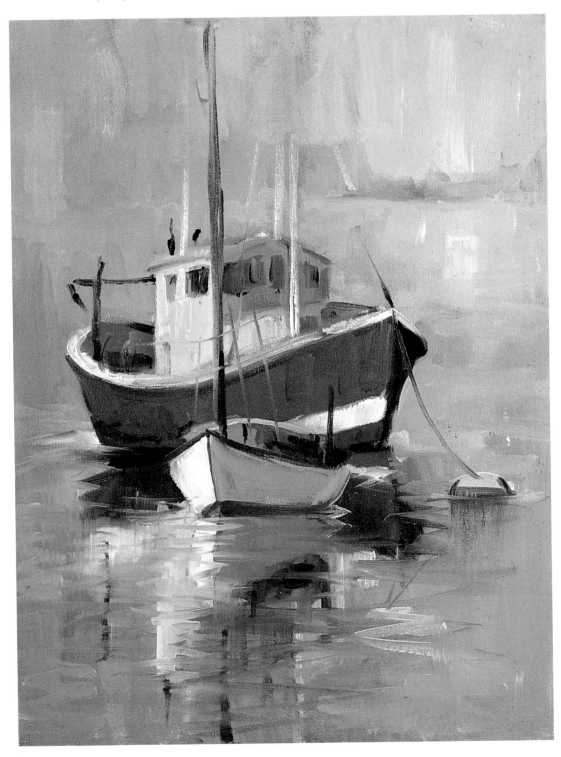

Dried Marsh Grass

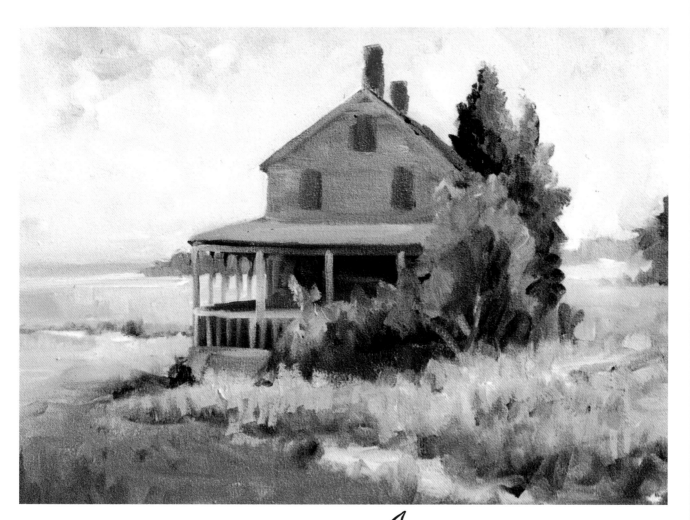

You so often see this subject matter peeking out from under the snow or you see big patches of it along roads and streams. *It's a favorite subject to use in the foreground for added interest.*

STEP 1. The basic tone of marsh grass could be white, Yellow Ochre, a little Burnt Umber, with a touch of Manganese Violet to gray the mixture down.

STEP 2. Add the upward stroke to this massed-in area with a mixture of white, Yellow Ochre, and a little bit of Burnt Sienna.

One trick to make dried grass look as though it grows out from the ground is to start your stroke at the ground and stroke up to the end of the grass pulling your brush away from the canvas as you complete this stroke.

When painting the grass hold your brush as you would a baton, and apply the paint with the side of the brush. The stroke follows the brush's handle. This is easier than holding the brush like a pencil and painting with its point.

Sunlight on Green Grass

Mass in the green grass area with a general tone of Yellow Ochre and a little Thalo Green mixed into light gray (Ivory Black and white). Or Chromium Oxide Green, Yellow Ochre, white, and a touch of Alizarin Crimson.

Now flash the sunlight across this basic grass tone with a mixture of Cadmium Yellow Light, and a little Thalo Green and white. Keep this mixture thick so it will drag over the basic tone and not disappear into it. You can even use some strokes to indicate the direction of the grass's growth.

Load the brush with the "sunlight color," press down on the canvas at the point where the grass is "growing," and pull the brush up just the way the grass grows out of the ground.

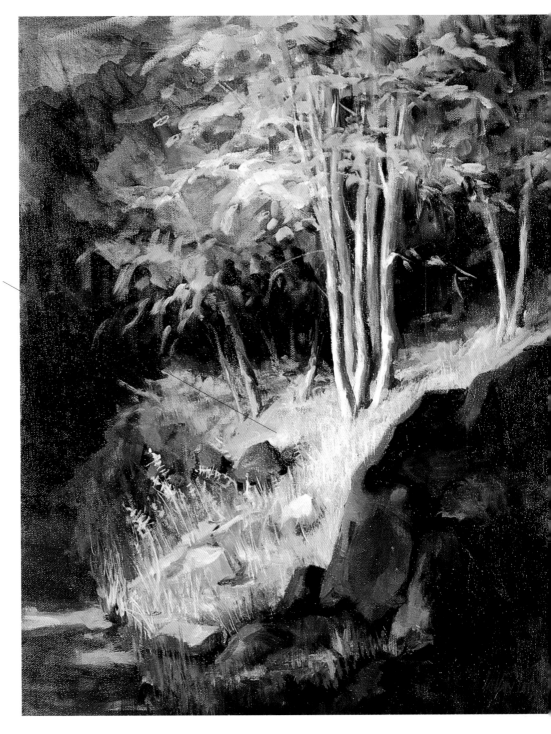

IMPORTANT: Always add the sunlight effect to a basic tone: don't paint the sunlight colors in first. Remember, you want to turn paint into the effect you want, so paint in the area first then add the sunlight.

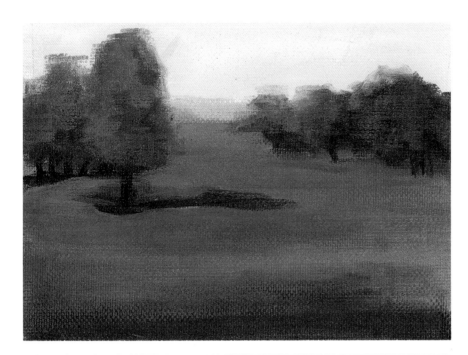

Notice how dark the value of the pasture must be. The lightness of sunshine can **only** show when it's flashed over a darker tone.

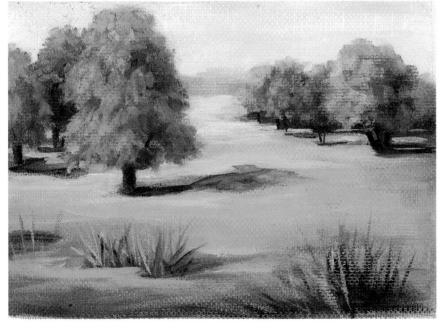

To flash on sunlight, hold your brush parallel to the canvas so you can drag the brush over the painted grass.

BASIC EXERCISES

Here and there show indication of blades of grass by dragging light up into darks (**A**) and by dragging darks into the lights (**B**). Arrows show direction of the strokes.

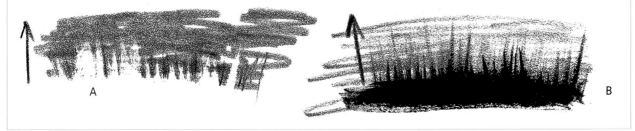

A

B

Mountains in the Distance

The colors of mountains in the distance will vary according to the seasons and the mountains' locale. It's hard, then, to give a general mixture for all situations. One factor that's general, though, is that any mountain's color in the distance has to be toned down in intensity. Keeping a color toned down or grayed is relatively easy by making a gray (Ivory Black and white) and *mixing color into it rather than starting with the color that you see.*

For example, if you see the mountains as a gray-blue, mix Ivory Black and white and then add blue (a touch of Raw or Burnt Umber into this mixture can't hurt it).

So often mountains in the distance look a violet blue. Make this color by taking Ivory Black, white, Payne's Gray, and a touch of Alizarin Crimson.

In the Fall many mountains take on a pinkish hue. Make this by using Ivory Black, white, with Indian Red. Or Ivory Black, white, with Venetian Red.

So often mountains in the distance *in the Spring* are in direct sunlight. They'll actually look greenish. Make this color with Ivory Black, white and Thalo Yellow Green. Or Ivory Black and white with Chromium Oxide Green and Yellow Ochre. To this last mixture, add a dash of Alizarin Crimson.

Remember:
to gray a color,
add a touch
of the color's
complement.

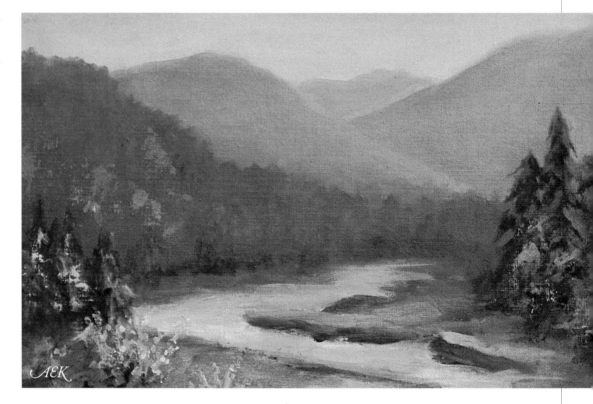

For the violet blue you may see in the distance, mix Ivory Black, white, Payne's Gray and a touch of Alizarin Crimson. In the fall, the pinkish hue you'll see can be made with Ivory Black, white and Indian Red. For spring season, use Ivory Black, white and Thalo Yellow Green.

In the Distance In the Fall In the Spring

Ocean Waves

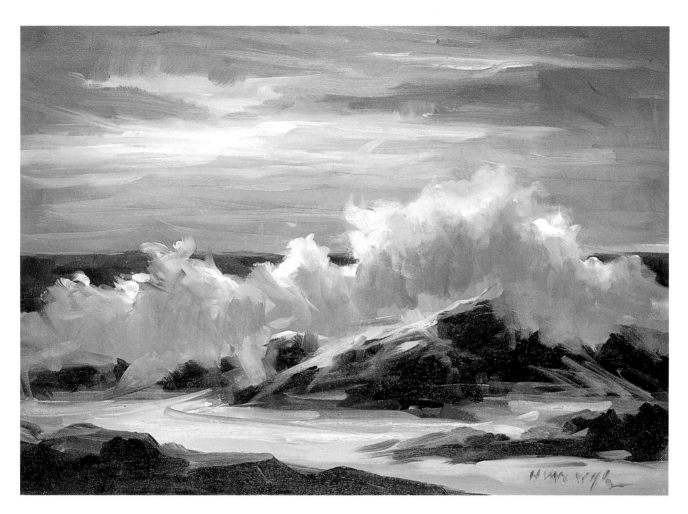

The spray and foam of breakers, known as "white water," present a painting hazard. The white water must look deep and full of turbulence. This can be done by painting it with more than one light value in contrast to the color of the water.

BASIC TONE:

Make a gray of Burnt Sienna and Ultramarine Blue mixed into white. *Don't be afraid to make this basic tone quite a bit darker than white!*

For a gray day: tip this gray to the warm side with more Burnt Sienna.

For a sunny day: tip this gray to the cool side with more Ultramarine Blue.

Add more white into this mixture with a touch of Yellow Ochre and add lighter areas to the breaker to show the source of light.

On a gray day: the lighter tones will be on the tops of the waves and on the flat planes of the water.

On a sunny day: the lighter tones are easier to find. They are where the light strikes.

Don't add foam, spray, or any other type of "white water" to an already painted ocean. This light value should be painted in as an initial part of your composition.

Reflections on Still Water

As you know, reflections in still water are upside down mirror images of the landscape. Strangely enough, this is *easier to paint* than water that hasn't any reflections. Conditions that are distinctive are *always* easier to paint than conditions that aren't too obvious. When painting reflections in water you have so much to latch onto. There are all the shapes and the colors of the objects that are being reflected.

To illustrate, here's a hypothetical scene of a gray shack with a red roof, on a light green area with dark green trees behind it. The whole scene is reflected in an inlet of still water. And in the water, tied to a brown post, is a blue rowboat.

STEP 1. Paint the water area with the same gray of the shack, the same light green of the grass, the same dark-green of the trees, the same red of the roof, and the same blue of the sky. Make sure all the applications of these colors are done with *vertical strokes.* Don't put the boat in yet!

STEP 2. Don't be afraid to overlap your strokes because all of these colors should fuse together slightly.

STEP 3. Now, with a big, soft, dry brush lightly stroke across (horizontally) the entire water area. The surface of the water will take on the appearance of laying flat. At the same time, the reflections will look as though they're in the water. If there's a slight rippling in the water, take a Size 14 red sable Bright or a size 8 Overture, and put half of it on one color of a reflection, the other half on another color of a reflection — for instance, the gray of the shack as it meets the green of the grass — and move the colors of these reflections together by wiggling the brush down the line.

STEP 4. With a light gray (white, a little Ivory Black, and a little Cobalt Blue) paint in the little lines of gray where the water meets the land.

STEP 5. Now, you're ready for the boat. First, wipe away the paint in the area where you want to place the boat. After the boat is painted, reflect the boat's color in the water, using *vertical strokes.* Do the same with the pole the boat's moored to. Then, affect these reflections with the same horizontal strokes that you used for the other reflections.

IMPORTANT: It seems that everything is best painted by massing in one direction and then affecting it with opposing strokes.

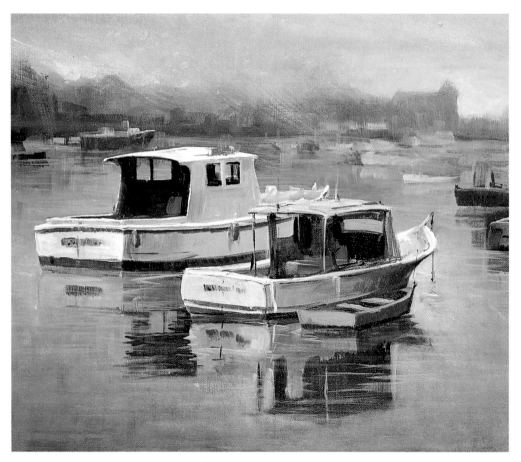

All these mixtures could be a little darker than the objects that are causing the reflections.

IMPORTANT: You can't ripple the water without first painting it still.

Paint the entire water area with the tones that you see, using vertical strokes. Notice, in the painting on top, how very still the water seems to be. If you want the water to ripple a little, move the tones of the very still water together with a little wiggle stroke, illustrated in the bottom painting.

Clear Blue Skies

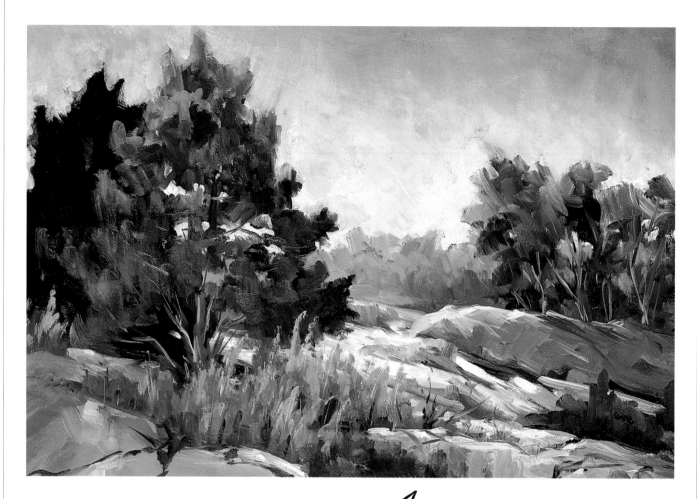

Clear blue skies can look very flat if they're painted with only blue. Here are some ways to paint a more luminous clear blue sky:

STEP 1. In the distance, where the sky meets the horizon, use Thalo Green and white instead of blue. To this mixture add more white and Thalo Blue as you see the sky coming toward you. As the sky meets the top of the canvas, add a little Burnt Umber and white to this mixture.

STEP 2. *Another way:* With a mixture of Burnt Sienna and lots of white, paint splotches of this off-white color over the sky area. Then, with a mixture of Cerulean or Manganese Blue and lots of white, paint splotches in between those made with the Burnt Sienna-white mixture. Mush these splotches together, and add any lighter (more of the Burnt Sienna-white mixture) and darker (blue mixture) values that you see in the sky.

STEP 3. Very often the far distant sky area will look far away if you add a touch of Light Red, Indian Red, or Manganese Violet to make the sky near the horizon darker and more violet.

For a darker version of this sky — a gray day, for instance — add all the colors mentioned into gray instead of into white.

At the horizon, use Thalo Green and white, then as you move up, Thalo Blue and white and as the sky meets the top of the canvas, add a little Burnt Umber and white to that last mixture.

Snow on a Cloudy Day

A difficult problem because you can't rely on strong contrasts to represent the mood. It's also difficult because of the preconceived idea that snow is white.

If snow on a sunny day is painted with white out of a tube, then snow on a cloudy day has to be *darkened* white (white darkened with black) which is always cool. We hardly get a chance to see snow that's cool in color on a cloudy day because *any sort of light* is going to present a degree of warmth. So, your problem in painting this type of snow is to mix a warm gray.

WARM GRAYS:

1. The *easiest* way: Ivory Black, white, Burnt Umber.

2. A *better* way: White, Ultramarine Blue and enough Burnt Umber to change this blue mixture to a warm gray.

3. Ultramarine Red, white, and a little Yellow Ochre. Add Ivory Black to darken to the value you need.

Surely you'll see faint variations in the tones of the snow. This color can be mixed by adding a bit of Ivory Black and Alizarin Crimson to your basic mixture. It could also be black and a touch of Viridian as long as your shadow indications are cool colors in relation to your mass tone.

Whenever painting a large area of one color, don't mass it in as though you were painting the side of a barn. Do it with slight variations of your basic mixture. This means if you have, let's say, black, white and Yellow Ochre as a basic mixture, cover the area with but a splash in a lighter version of this mixture and also a darker version (addition of a touch of Cobalt Blue). The variations in color will give the massed-in color a chance to look more dimensional.

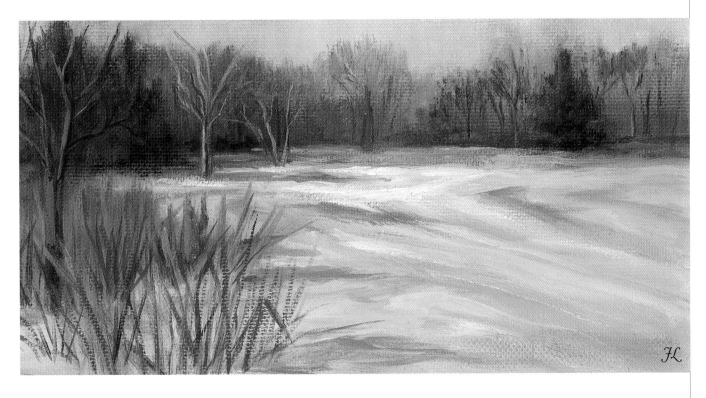

The mixtures at left offer you three options for painting snow.
1. Ivory Black, white, Burnt Umber.
2. White, Ultramarine Blue and Burnt Umber.
3. Ultramarine Red, white and a little Yellow Ochre.

Sun on Cold Stones

In painting it's a truism that anything that has sun streaming on it has to be a warm color. Sunlight, of course, is warm. Any color that's bathed in sunlight will look wrong and won't be illuminated if it's not warmed. The painting problem is how to make cold-looking gray stones that are bathed in sunlight *appear* to be in sunlight.

First, we need a basic gray stone color: Ivory Black and white, Thalo Blue and some Burnt Umber.

You may add into your stone color any of the following colors plus white: Burnt Sienna, Cadmium Orange, Yellow Ochre, Raw Sienna.

It's best to have the stones already painted in a more general value than they are. Then you can take your sunlight mixture and flash it on every stone plane that faces the sun.

Remember: the brighter the light source the darker the cast shadows will be.

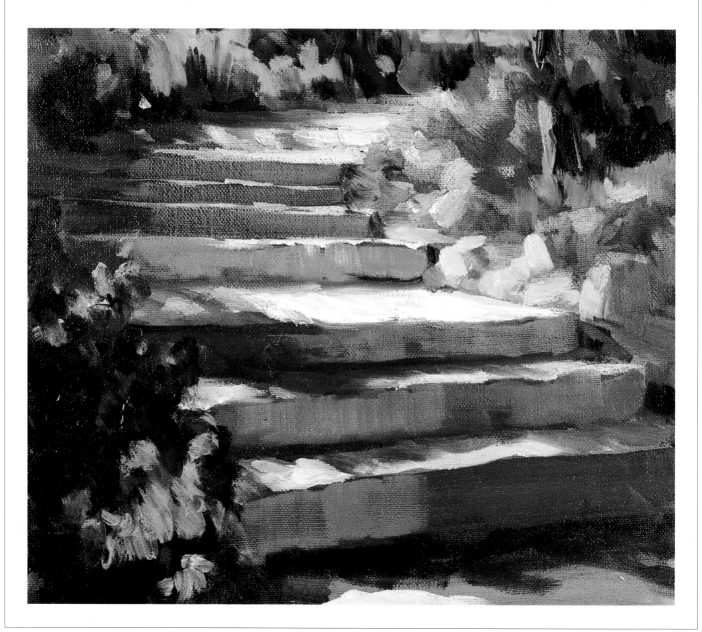

Birch Trees

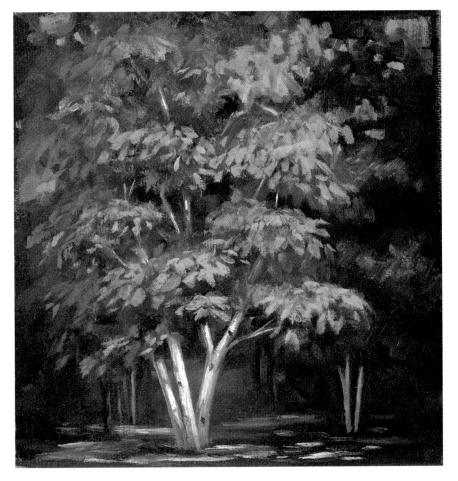

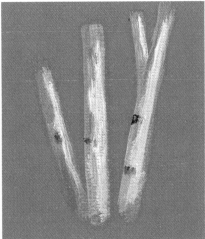

Shown here is a detail of birch trunks. These were painted by mixing Yellow Ochre, Burnt Umber and white. They've been shadowed by adding Ultramarine Blue and Alizarin Crimson to the basic mixture.

Here's that problem of painting white again. The preconceived idea that birch trees are white with black lines stops many from painting them properly. Surely, if the trees are in the foreground, you can paint them light with lots of white. However, if they're in the distance or middle distance, they have to be darkened white, otherwise they'll look like white lines of bare canvas.

BIRCHES IN FOREGROUND:

Mass in a general tone made of Yellow Ochre, Burnt Umber, and white. Shadow the birch trunk by adding Ultramarine Blue and Alizarin Crimson to the basic mixture. If this isn't dark enough, or seems too violent a violet, add Ivory Black.

For the light striking the birch trunk, mix a little Yellow Ochre into a lot of white. Load one side of a flat brush by scooping into the paint puddle on your palette. Don't stroke this color in a downward motion. Pile the paint in horizontal strokes on the trunk. If these pats of lighter value are added intermittently, the basic tone will show up and remain as the textural dark circles that are so characteristic of birch trees.

A foreground birch is very apt to have a reflection of color in its shadow. This is often Raw Sienna mixed into a gray made of Ivory Black and white.

BIRCHES IN MIDDLE DISTANCE AND DISTANCE:

A middle distance birch can be easily painted with a warm gray, like white and Burnt Umber with a touch of Ivory Black. Birches in the distance need hardly be indicated. In order to keep them in the distance, however, a cool gray should be used: Ivory Black and white with any one of the following: Alizarin Crimson, Cobalt Blue, Ultramarine Blue, or Viridian.

Helpful Hint: We think birch trees are white. Not completely. The rest of the tree — everything except trunk and main branches — is dark. Don't paint everything "birch tree color." Study the tree. Don't paint your idea of the tree.

Trees in the Distance

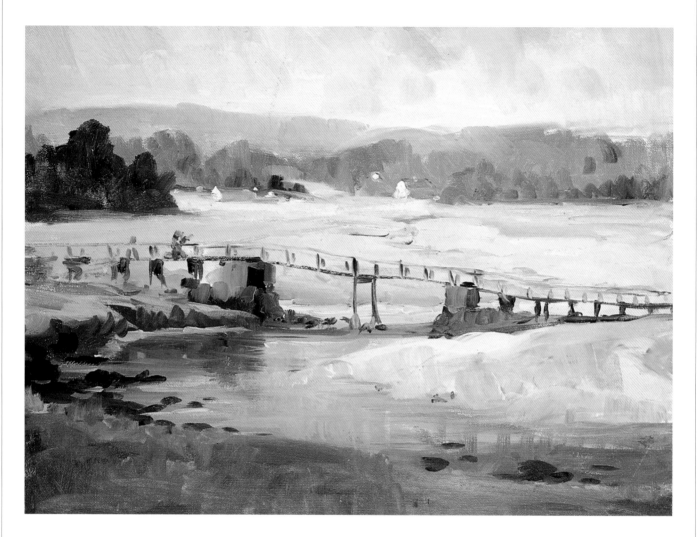

The best way to make this mixture correct is to look for the darkest dark of the subject you're working from, be it a colored slide, a full-color post card, or an on-the-spot observation.

Now judge these darks in actuality. Notice the tone they have to be in relation to what you've decided to be the darkest dark.

It's a good idea to "splot" (a combination of spot and splotch) a dark tone for the darkest dark of the landscape in its general location on the canvas, and also to splot the lightest light on your canvas.

Now you're ready to determine the tone of the dark trees in your picture's background. They're basically Thalo Green, Burnt Umber and Cadmium Orange; or Thalo Green and Ultramarine Red; or Thalo Blue and Cadmium Yellow Medium.

These mixtures will have to be altered with gray (black and white) to adjust their value in relation to your lightest light and your darkest dark.

Remember: In the distance no color can be intense. It has to be lightened and grayed to keep it in its place.

Evergreen Trees in the Foreground

These dark green-colored trees are found near the ocean, in the mountains and are often shrubbery around buildings. One good mixture: Thalo Green (or Viridian), a touch of Burnt Umber and white.

To shadow this color, add Alizarin Crimson.

To give you the lighter gray quality of the foliage, mix Ivory Black and white into the basic tone.

A good way to paint the trees is to mass them all in with shadow color and then add the lights.

Other good mass tone mixtures: Viridian with a breath of Alizarin Crimson or Cobalt Violet. Chromium Oxide Green and Ivory Black. Or Payne's Gray with either Cadmium Yellow Light or Yellow Ochre. To make them go farther back in the distance, add light gray.

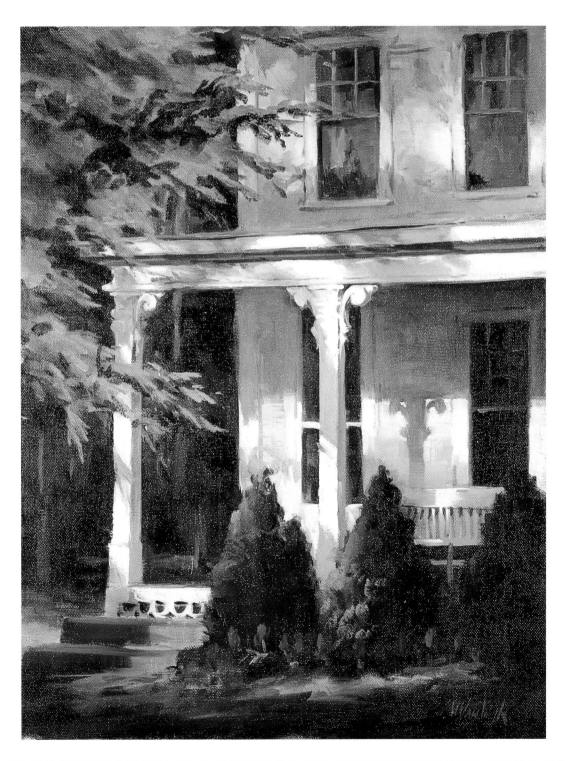

Forest of Leafless Trees

The problem of painting leafless trees often provokes the painter to get involved initially with the twigs. But when you look with half-closed eyes (actually, it's a squint) at a cluster of leafless trees, *all the little twigs become a mass of value* in contrast to the surroundings. The color of this mass is what you should distinguish; it's always a grayed color and often a gray pink, which you can make by adding Light Red into Ivory Black and white, or Burnt Sienna into Ivory Black and white. Don't make the mistake of painting them brown just because you know they're brown.

Naturally, if these masses of trees are far in the distance, this gray has to be lighter and blue instead of pink. In that case, add Ultramarine Blue and white into the pink mixture for forests that are farther back in the distance. A large round bristle brush is a handy implement to form the mass against the sky since the silhouette seems to be many rounded little shapes.

Into this mass color, add some Burnt Umber and a touch of Ivory Black for trunks of trees and larger branches. Start painting the trunks *from the ground up;* the branches *from the trunk out.*

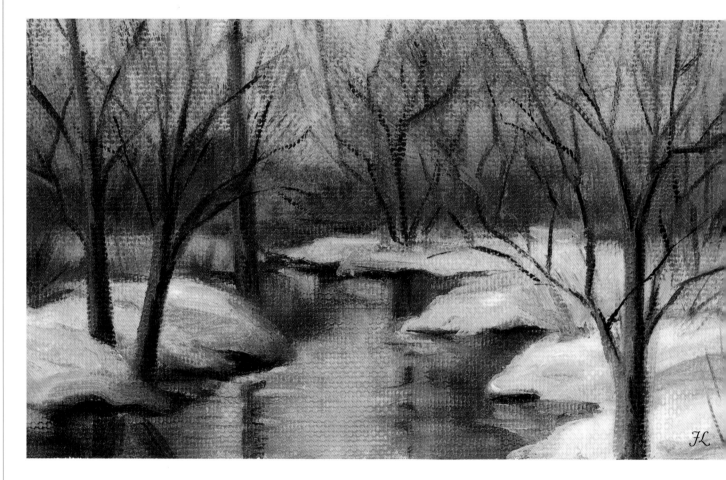

Remember: the entire shape of the mass, or element, is more important to the composition of the picture than the details of that mass. Details are a finish not a beginning.

You can't make a cake by starting with the icing.

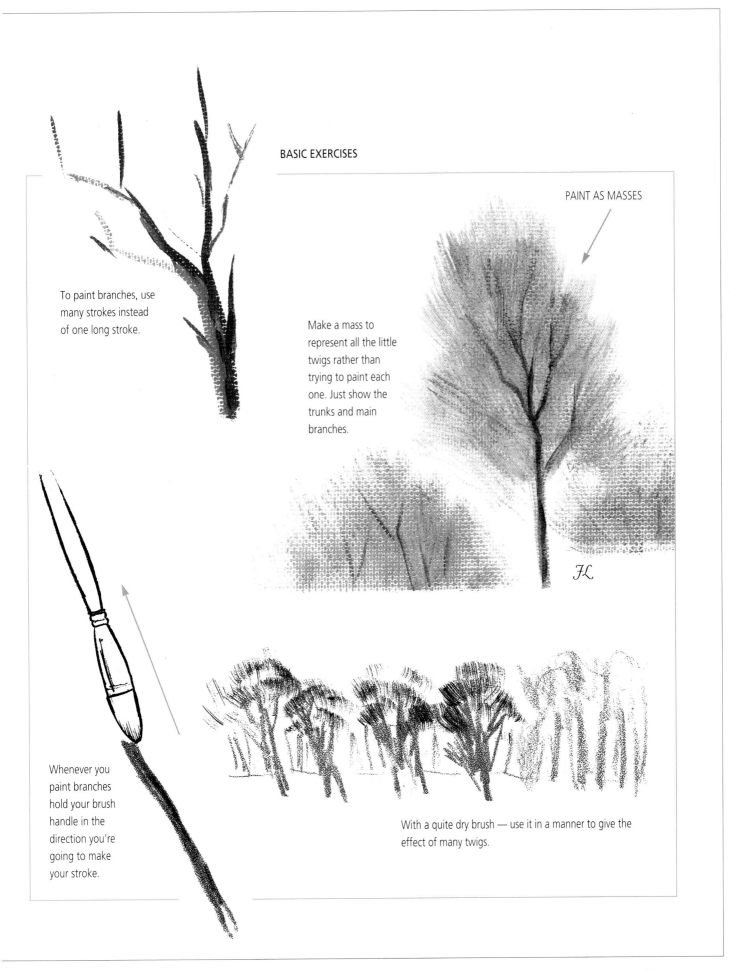

BASIC EXERCISES

To paint branches, use many strokes instead of one long stroke.

PAINT AS MASSES

Make a mass to represent all the little twigs rather than trying to paint each one. Just show the trunks and main branches.

Whenever you paint branches hold your brush handle in the direction you're going to make your stroke.

With a quite dry brush — use it in a manner to give the effect of many twigs.

Windows of Houses

Speaking generally about windows, whether on houses or barns, in the foreground or in the distance, keep them in their place. Paint them in detail only when they're in the foreground, and reduce them to mere indications when they're on buildings in the distance.

The dark rectangular patch that's the window itself is a comparatively easy mixture: a warm gray made by mixing Ivory Black and white and Burnt Sienna together. If this mixture isn't gray enough it won't look as though there's a pane of glass.

The problem of windows is usually in the area of painting the frames. These frame colors are so often lighter than the buildings themselves, and more often white, except on white houses; they're usually dark in that case.

The mistake is usually to make these frames too light and too sharply delineated. Here, then, an easy way to paint *a window with a white frame on a dark building:*

STEP 1. With a broad brush paint a rectangle of light gray (Ivory Black and white) to indicate both frame and window.

STEP 2. Paint the color of the structure around this rectangle, cutting it down to the size you want.

STEP 3. Take the Burnt Sienna and gray mixture on a smaller Bright brush (white bristle, red sable or my Overture) and paint the panes, leaving the light gray as frames. You'll find this is a better way than trying to paint the frames over the pane color. This procedure applies to any light frames on a dark building.

Dark windows, frames, and shutters against a light building: In this case always paint the house without the windows, then paint these dark rectangles into the house color. This helps to make these windows and doors seem like part of the plane or side of the house that they're on.

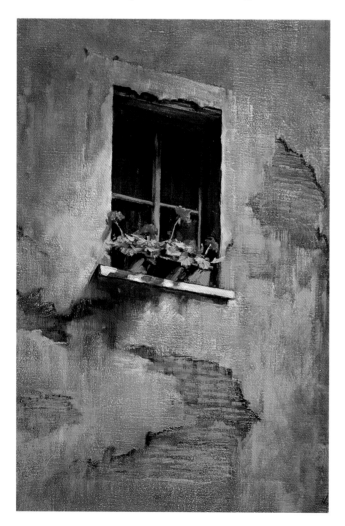

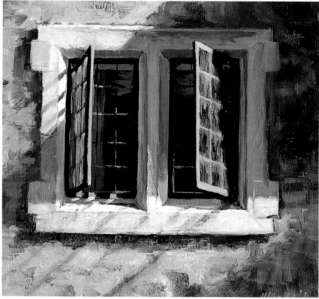

The details of windows that are pictured here are from paintings that were inspired during one of my many trips to Italy. Yellow Ochre and Raw Sienna dominate in the Italian villages just as white siding and natural shingles inundate New England's homesteads.

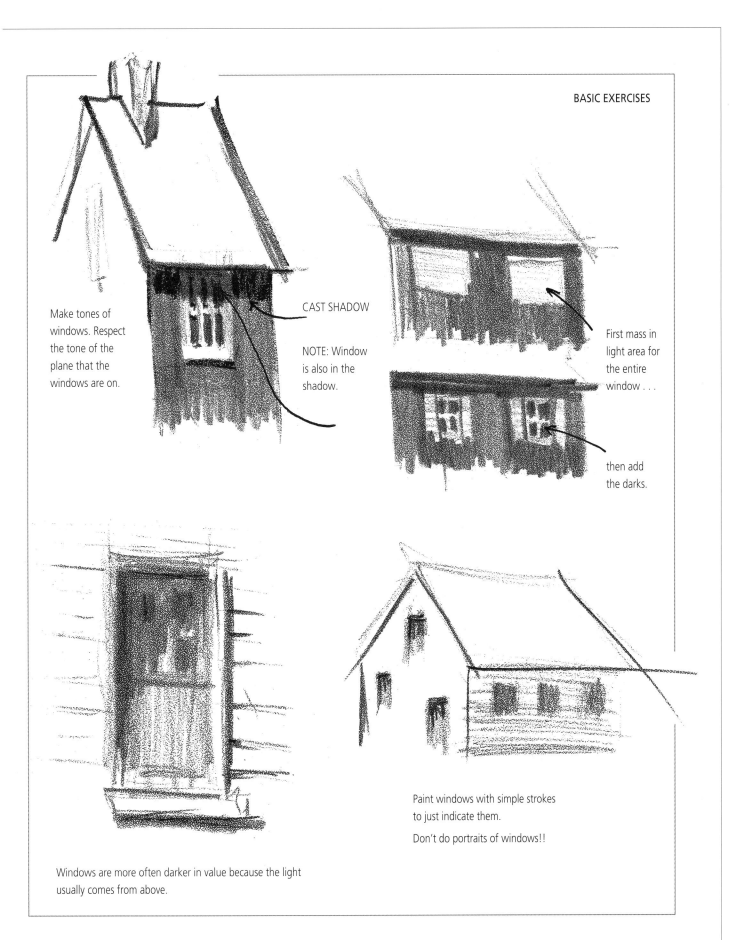

Make tones of windows. Respect the tone of the plane that the windows are on.

CAST SHADOW

NOTE: Window is also in the shadow.

First mass in light area for the entire window . . .

then add the darks.

Windows are more often darker in value because the light usually comes from above.

Paint windows with simple strokes to just indicate them.

Don't do portraits of windows!!

Old Wood

The texture of wood, such as knotholes and grains, is a characteristic that presents a painting problem not so much in the distance but in the close-up views. *Remember,* anything made of wood is a construction and this factor must be recorded first. This construction can then take on a further descriptive dimension by becoming knotty pine or weathered cedar.

A RULE OF THUMB:

Add textural effects to *already painted areas.* If you try to paint the texture while you're actually constructing the barn, it might interfere with the way you're doing the construction. So, add the feeling of grain and knots as a patina over a dried painted area of gray-brown (Ivory Black and white with Burnt or Raw Umber). You could streak it with a very thin, mixture of Burnt Umber or Burnt Sienna to give the effect of graining.

This is often best done with a soft cloth rather than with a brush. Use the brush, then, only for knotholes and accents.

Any additional layer of paint over an already painted surface is best done by glazing, because this process only affects the area rather than repaints or covers it. A glaze *never* has white in it, therefore it's transparent and doesn't cover what it's painted on; it only "colors" it. A glaze only imparts an effect to an area because it's *always a thinned mixture of paint.* A basic thinning medium to make paint "glazable" is linseed oil mixed in equal parts with turpentine. The advantage of using a glaze to add textural effects is that when it's applied to the tone of the painted area, *it respects that tone.* The same glaze can be painted on the browns that are in the light and the browns that are in shadow.

Painting knotholes, like dew drops (page 103), is a lot of fun and because of that there's a tendency to overdo them. First, your wood color has to be dry. Then, with a darker color than you used for the wood, paint the shape of the knothole. Next, with the same color mixed into white, add the lights and, finally, the highlights, using an even lighter color.

COLOR RECIPES FOR

Portraits

"So you want to be a portrait painter," were among the first words M. A. Rasko spoke to me. He then proceeded to teach me everything about painting *except* portraits. Eventually, I got around to painting the human face, but before that happened, I had painted a lot of apples. "If you can paint an apple," Rasko maintained, "you will be able to paint a human head. An apple has a skin, a texture, and each apple has a distinctive shape just like each individual person."

In my pursuit to learn portrait painting, I found myself involved with hours and hours of still life painting. I later learned, and know now quite emphatically, how important still life can be to every portrait painter. A knowledge of painting drapery, for example, will make painting your model's clothing much easier to do.

Painting a portrait as you can see, is not only a matter of painting a person and getting a likeness. Among other factors, you need a good composition (which all paintings *must* have); how big to make the head and where to place it on the canvas; and you need a background that looks like the model lives in that environment. You must be aware of the background's color in relation to the flesh tones and apparel of the model.

Another factor of portrait painting is the way you deal with your model. For one, you don't want to work on portions of the painting that don't really need the model to sit for you. Placing the model on the canvas is one such occasion, a background, hands, and clothing are others. Photographs can substitute very well for the model in these cases. In my first sitting with my model, I spend the entire session taking a bunch of photographs. Incidentally, I never use flash when taking these photos, but set up my lights to give me one light source that presents a good strong shadow.

This book, however is about color mixing. The *Color Recipes* in this section will guide you to paint believable looking features of the face, hair, and the clothing that a model may wear. While there are instructions for the procedures you may employ, the emphasis is on the color of things.

Basic Brush Work

Many textures can be obtained by striking the paint on one way and effecting it with a stroke in the opposite direction. Of course, we have to study each texture to find out the direction to go first.

HERE'S A GOOD, SIMPLE RULE:

Always leave the obvious direction of the texture for your final stroking.

STEP 1. The Basic Tone.

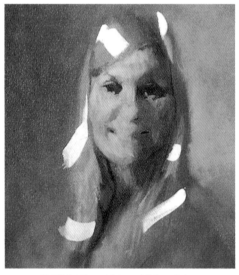

STEP 2. The addition of lighter lights.

STEP 3. The blending of lights with combing strokes.

STEP 4. Adding a lighter highlight.

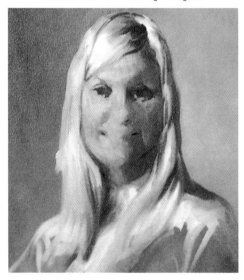

STEP 5. The highlight blended in.

Background for Portraits

The background functions as an environment in which the subject resides. This means making it appear that the background actually goes behind the model. You can't accomplish this by painting the background carefully up against the periphery of the figure, as I've seen hundreds of students do. You have to first cut the background color *into* the figure and repaint the figure out into the background. Doing this will help you to use found-and-lost edges to add to the dimensional effect. The model shown here is the lovely Fiona Nemes, a mature ten-year-old when the portrait was painted.

A background color can make or break a portrait. A safe, neutral one to use is gray. And since we enjoy warm colors more than cool ones, because they're like the warmth of sunlight, the gray you use should be a warm gray. When I speak of warm gray I refer to colors such as: eggshell, ecru, beige, light tan, bone white, to cite a few (see how many others you can name).

A mixture of pale gray (white with a touch of Ivory Black) with any of the following colors: Burnt Umber, Yellow Ochre, Raw Sienna, Burnt Sienna, or Cadmium Orange, will surely give you these types of grays. But their use in the background area, applied either smoothly or in a varied way, will still not give you the full effect of a warm gray background. In order to get it, try this method: Before using any of the suggested mix-

tures, splash dabs of a light-toned mixture of Alizarin Crimson, Thalo Green, and white in intervals over the background area. Now, use the first mixture to blob in between these dabs of cool color (the Alizarin Crimson-Thalo Green mixture).

With a lighter version of the first mixture (more pale gray mixed in) try to meld these blobs together. Your eye will see an effect that takes on the appearance of atmosphere. Don't think this will happen the first time you try it; it takes some practice for the eye to recognize a solidification in paint of the phenomenon of space on a canvas. This is what a background's supposed to be: a colored environment, not colored paint that outlines the person.

Eyes

The whites of the eyes are *only* whiter than the flesh color that surrounds them. They *seem* like white areas because they serve as backgrounds for the usually quite dark irises. *By no means are the whites of the eyes as light as white paint.*

To make the eye look like the ball that it is it's best to utilize the trick of light and dark to show the eye's dimension. This certainly eliminates making the whole white of the eye area one value. Also the whites of the eyes should be darkened or shaded because they're in the sockets of the eyes and much of them are shadowed by the brow and the lid.

STEP 1. Make the white-of-the-eye color by mixing Ivory Black and white into your flesh color so the whites of the eyes won't be a shocking change of color and value to the rest of the face.

STEP 2. Naturally, the white-of-the-eye area is delineated by the shadow caused by the upper lid and the iris.

STEP 3. Add more white into this grayed flesh mixture and lighten the white of the eye where it's in line with the light, more toward the bottom lid than the top one.

STEP 4. A way to make the eye look moist is to put a highlight of a very light gray between the white of the eye and the lower lid. This makes the eye look as though it floats in its natural lubrication. Don't overdo this highlight: you can end up making your model look hung-over!

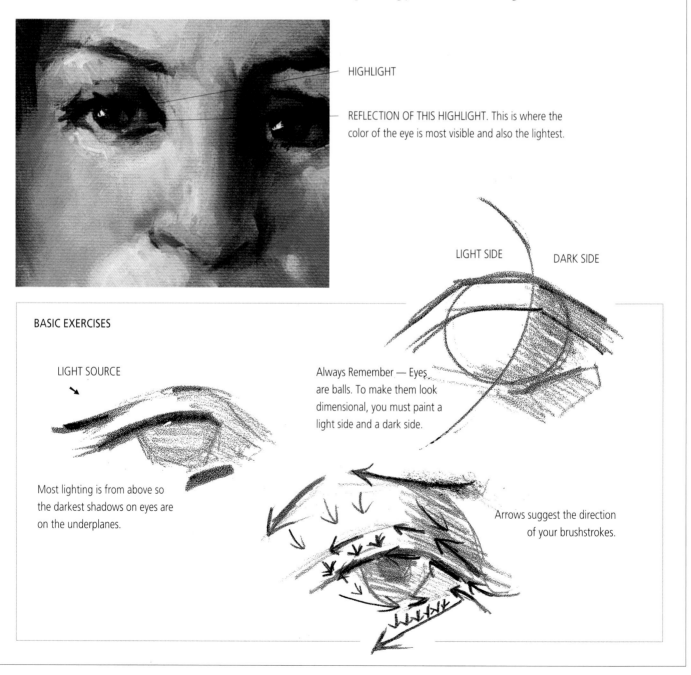

HIGHLIGHT

REFLECTION OF THIS HIGHLIGHT. This is where the color of the eye is most visible and also the lightest.

LIGHT SIDE DARK SIDE

BASIC EXERCISES

LIGHT SOURCE

Always Remember — Eyes are balls. To make them look dimensional, you must paint a light side and a dark side.

Most lighting is from above so the darkest shadows on eyes are on the underplanes.

Arrows suggest the direction of your brushstrokes.

Eye Glasses

EYE GLASSES WITH BLACK FRAMES:

The biggest mistake is to paint them too dark with just black paint. It's better to mass them in with Ivory Black lightened with white, some Cerulean Blue, and Raw Umber. Then you can use Ivory Black with a touch of Ultramarine Blue for the shadows. Where you see the highlights, use very light gray (Ivory Black into a lot of white).

The highlight is always best applied by loading a brush and then piling it on. My favorite brush is a #14 red sable Bright (short, flat shape) because of its razor-sharp edge. Since the price of this brush may stagger you, I recommend my Overture Brushes, in this case a size 8. I mix my highlight color, wipe the brush clean, then push the sharp edge into the puddle so I have the edge loaded with paint. I wipe one side of the brush with my rag, leaving the paint only on the edge of the other side of the brush. I then pat this highlight on.

It's important that you paint the eyeglasses together. To explain, paint the top of the frame over one eye then repeat that stroke over the other. Do the same with the sides of the eyeglasses and finally, with the bottoms of the frames.

The model at top is my husband, Herb Rogoff, who has posed many times for me. He's in good company here, with the Honorable S. Basile as his "pagemate," to coin a word.

Eyebrows

Students don't paint eyebrows the wrong color as much as they make them look pasted on and artificial.

IMPORTANT: The area where the eyebrow grows is also the top ridge of the eye socket.

Feel your own eyebrow. Run your finger along the hair, starting at the nose. Your finger will travel in *two directions:* along the front of the face; back onto the side of the eye socket. These two directions — across and back — tell you that you have to paint the eyebrow in *two strokes* in order to help indicate these two planes.

Never start at the nose and draw them in like you'd do with an eyebrow pencil. Women students know that even an eyebrow pencil must be used with short strokes.

Put in all eyebrows — no matter their color — with a mixture of Ivory Black and white and a little Burnt Umber. Very gray.

Now, for the *browner* type of eyebrow: mix a little Burnt Umber with Thalo Blue or Ivory Black and add the darks.

It's amazing how a big round brush can be used for eyebrows when used this way: saturate the brush with the "eyebrow mixture" and then rub the brush over a Turkish cloth to dry it. This action will also "fluff up" the end of the brush a little. Then, in light, little strokes, or pats, accentuate the shape of the model's eyebrow.

Have some flesh color on another brush and use it to blend the eyebrow color and the flesh area together.

The darkest part of the eyebrow is never along the upper ridge where it meets the forehead; it's more under the eyebrow to show the thickness of the hair.

Helpful Hint: The eyebrow is always lighter where the two planes meet at the corner.

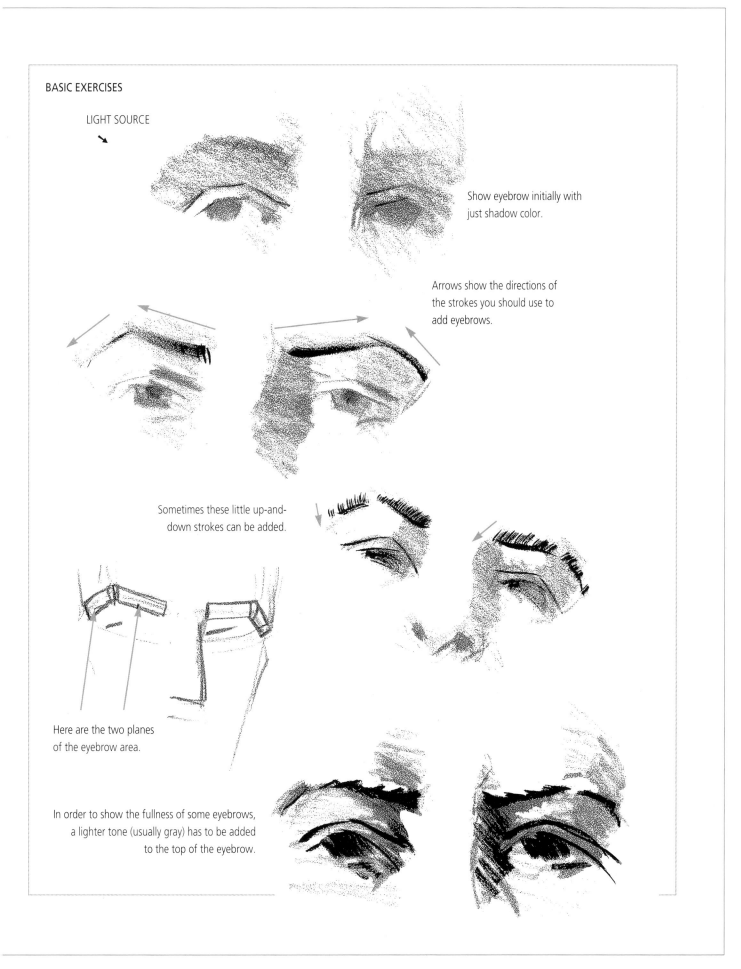

BASIC EXERCISES

LIGHT SOURCE

Show eyebrow initially with just shadow color.

Arrows show the directions of the strokes you should use to add eyebrows.

Sometimes these little up-and-down strokes can be added.

Here are the two planes of the eyebrow area.

In order to show the fullness of some eyebrows, a lighter tone (usually gray) has to be added to the top of the eyebrow.

Ears

Mass in the ear shape in a redder and darker version of your flesh color. To make this, add to your flesh mixture some Light Red (or Venetian or Indian Red) and a small touch of Viridian.

BASIC FLESH:

Yellow Ochre, Cadmium Red Light, and white. To make the shadows, use Indian Red with a touch of Viridian or Thalo Green.

Now you can inject more dimension to the ear by adding lighter tones to the lobe and outer rim. This can be done by using basic flesh or Light Red into white. To get the interesting transparency that ears have, put some Light Red into the shadows to record the reflected light.

Helpful Hint: *Any hair of your model that extends over the ears should be painted after the ear has been completed. Always paint the ear darker and duller than the rest of the flesh, especially if it's semi-covered with hair.*

A human ear is shown with all its anatomical detail. You never want to paint your model's ear in this manner. You'll end up with a portrait of an ear with a man (or woman) hanging nearby. Just make an indication of an ear as I did on the portrait of my cousin, John Stap.

Facial Hair

A great many people think it's easy to get a likeness of a man with a mustache or a beard. This may be true if the artist is just doing a caricature. But a painting seeks to be more than that. The likeness in a painting is making skin look like skin, hair look like hair, as well as getting a particular likeness of an individual. Beards and mustaches are additional trouble, because they have to look like hair growing out from the skin.

BEARDED AREA OF A MAN:

Painting the bearded area presents two dangers: Too much beard will make the man a bluebeard. Too little beard will make him less of a man.

Here's the basic mixture: Use your own discretion. The bearded area is a toned down flesh mixture of white, Cadmium Red Light, Yellow Ochre, Burnt Umber, Cadmium Yellow Light, and — according to the degree of "five o'clock shadow" — a little Ivory Black or Ultramarine Red.

The appearance of a beard is mostly indicated by the kind of highlight you use on the chin. It's light gray: Black and white with a little Alizarin Crimson.

The word "bluebeard" can lead you astray when painting the bearded area. You can't make it a cool color, especially where the light strikes the bearded area, because cool colors

recede, and the bearded area must project right along with the face it's growing on.

A dark beard is treated the same way as a mustache. but when painting a big beard, make sure you paint the neck and collar before you paint the beard over them. Since the beard is the last to grow, it's the last thing you paint.

DARK MUSTACHE:

STEP 1. A dark mustache has to be massed in initially in a value not as dark as the mustache. A good mixture: add some Ivory Black and Burnt Umber, with a touch of Light Red, into the basic flesh mixture. Stroke this mixture in across the lip in a direction that's opposite to the hairs. By making this mixture darker with a little Ivory Black and Alizarin Crimson, add the shadows that you see, usually under the nose (cast shadow) and the bottom edge of the mustache which shows its thickness.

STEP 2. With a little flesh color on your brush pull some flesh color down into the mustache area around the top edge of the mustache. This will make the hairs look as though they're growing out from the skin.

STEP 3. With a small round brush make some vertical strokes of a medium light gray (Ivory Black. white, and Burnt Umber). This will accentuate the fullness of the mustache.

Helpful Hint: It's much better to paint more skin than is visible so you can creep into that flesh color with your darker beard color to paint the beard's form as it meets the skin.

Blond Hair

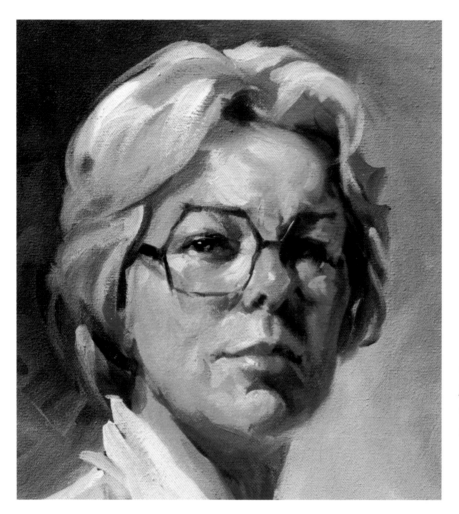

Don't make the hair pattern the same on either side of the face, even if you see it that way.

Since long straight hair is always in vogue, I'll relate this *Color Recipe* to that particular hair style.

STEP 1. *Mass the hair shape* in with a mixture of white, Yellow Ochre, Raw Sienna, and Burnt Umber. This mixture shouldn't be the lightest color that you see in the hair. *Don't make the paint too thick;* it should cover the canvas adequately.

STEP 2. Work on the outline of this mass as it meets the background until the edge is soft (see the *Color Recipe* "The Hairline as it Meets the Face, page 78). If any hair falls over the face, the face has to be painted before you work on the hair. Join the hair tone nicely to the area where it meets the body.

STEP 3. Make a mixture of Alizarin Crimson, a little Thalo Blue, and a breath of Burnt Umber (really a grayed violet) and paint in all the shadows. These shadows are on the underplanes and on the planes of the hair that are away from the light.

STEP 4. Now, mix Yellow Ochre and white and paint in the lighter areas as you see them. Don't paint your strokes in the direction that the hair is combed, but *in a direction that's exactly opposite.* You can then fuse the lighter application into the basic tone with a stroking action that's very much like combing the hair. A large dry, soft brush is very handy for this "combing" process.

STEP 5. Mix Alizarin Crimson and white and a little Cadmium Yellow Light in a very light value, and stroke this highlight color on the already lightened areas in the same way as in STEP 4, putting it on opposite to the way that you comb the hair.

STEP 6. With some Burnt Umber you can add some dark accents.

STEP 7. Some blond hair may have some greenish yellow in areas. Get this by mixing: *For dark green passages:* Cadmium Yellow Medium with Burnt Umber. *For lighter gray areas:* Ivory Black and white (a light gray) and a little Cadmium Yellow Light.

Black Hair

Mass in the hair area in a mixture of Ivory Black, white and Burnt Umber to get a value much like gun metal.

Shadowed areas of hair can be made by adding Burnt Umber and Thalo Blue to the basic tone.

Highlights: Ivory Black and white with a touch of Alizarin Crimson. Or Ultramarine Blue. Or any blue or violet.

For the darkest darks of black hair (the accents in the shadowed areas): Burnt Umber, Alizarin Crimson, and Ivory Black.

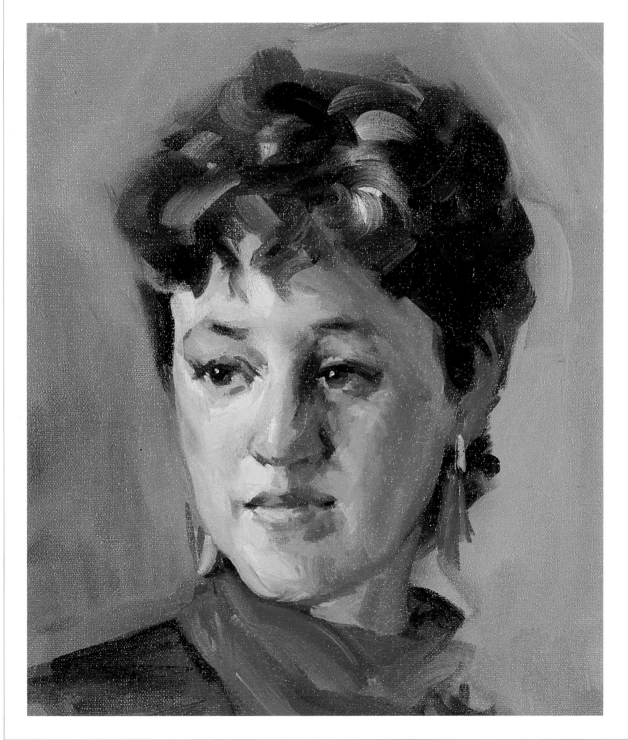

The Hairline

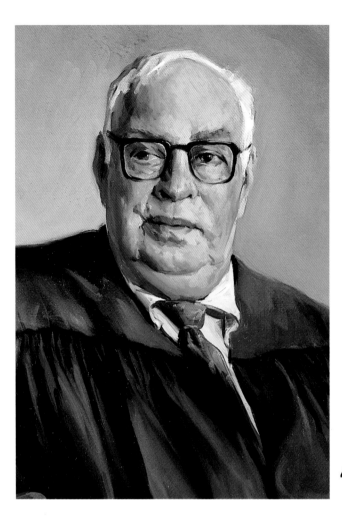

This fragile area — much the concern of many men — is very difficult to paint. If a person isn't aware of its subtlety, *the hair could look more like a wig than its natural growth.* So often the hair tumbles over the forehead; you must paint it in a way so it looks as though the forehead is *under* the hair.

In painting, it's so easy to react to what is obvious. The subtleties of what we see should be sought out and painted first. Instead of painting the hair color against the face, paint a little darker cool gray, made of Ivory Black, white, Alizarin Crimson, and Cobalt Blue, around the flesh area and fuse this color that's slightly darker than flesh into the flesh.

You can then sneak the hair color into this gray area by starting your stroke *in the hair mass* and coming *toward the hairline area,* pulling your brush away at the end of the stroke. This stroke is a reverse combing action, going toward the hairline instead of away from it.

Wipe your brush between each stroke with your rag. I think a good rag is as important as a good brush. I use small (4" x 4") pieces of Turkish toweling to control the amount of paint that I'll have on my brush.

BASIC EXERCISES

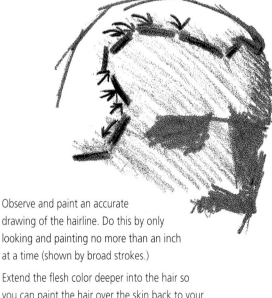

Observe and paint an accurate drawing of the hairline. Do this by only looking and painting no more than an inch at a time (shown by broad strokes.)

Extend the flesh color deeper into the hair so you can paint the hair over the skin back to your original line. These strokes are indicated by arrows.

Often a hairline is the result of the hair casting a shadow on the face. So, look for values rather than lines.

Keep the line between the hair and face very fuzzy on the shadow side.

Hands in a Portrait

Because hands are so hard to paint I try to avoid including them in my portraits. I pose my models in such a way that the hands could either be disguised or I could get away with fading them out of focus.

However, in those portraits where hands have to be included, I pose them in the easiest view possible. This could be with the fingers bent or the hands holding some object.

Always paint the hands in flesh tones that are *darker* than the one you use for the face. This prevents the hands from being too obvious. Make this hand-flesh color by mixing Yellow Ochre and Light Red into a gray that's #4 on the Value Scale.

One way to make a hand take form is to use *sharp and fuzzy edges* around the hand as it meets its background.

Make the edge fuzzy by mushing the outline of the hand into the background color. Do this easily by rubbing your thumb over the edge.

Make the edge sharp where that edge comes at you. Leave all other edges that turn into the picture fuzzy.

Don't make the fingernails a different value or color from that of the flesh of the hands. Use a lighter gray highlight to describe the nails, and this should be sufficient.

Helpful Hint:

This hint not only applies to hands but to almost everything else. If something you see in your painting doesn't look right while you're painting it, wipe it out and start again. It's better to do it this way than to rework it and pick at it, making your mistake bigger and getting that labored look.

Lips

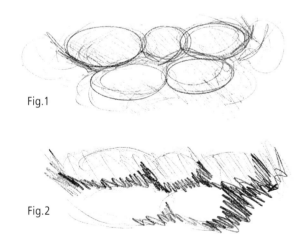

Fig.1

Fig.2

The mouth is constructed of five muscles, three on the upper lip, two on the bottom. While mouths on humans vary from one person to another, every mouth has these five muscles. You can see these muscles in Fig.1, in which they are roughly indicated, and in Fig.2, which has dimension added.

Generally, the upper lip is darker than the lower lip.

LOWER LIP:

For a natural colored lip (no lipstick):White, Yellow Ochre, and Cadmium Red Light, with more red than the Yellow Ochre. As the lower lip seems to darken, add Alizarin Crimson to the mixture. Where the lower lip seems to be lighter, use Cadmium Red Light and White.

UPPER LIP:

Mix Gray (Ivory Black and White) and add Cadmium Red Light. For the line between the two lips, add Alizarin Crimson to the upper lip color.

For Men: Use Venetian Red or Light Red instead of Cadmium Red Light for every mixture.

For Women with Lipstick: Add Grumbacher Red into the mixtures, or glaze with Alizarin Crimson or Grumbacher Red after the lips have dried.

Glaze: The color thinned with any medium (except only turpentine) applied over a dried area. A glaze always imparts more color.

Noses

What feature of the face is the most difficult to paint? Many think the *eyes* are. The eyes hold an advantage because they show expression. The same thing holds for the mouth. The nose, however, doesn't enjoy that advantage. It's a form parked right in the middle of the face. This is hard to show on a mere flat surface because it must look as though it sticks out from the face.

When posing your model make sure you *use lighting that flatters the nose.* Here are some "don'ts": *Sharp Nose* — Don't light from above; this will cast a mustache-like shadow on the upper lip. *Broad Nose* — Don't light from the side; this will accentuate the thickness of the nose. *"Pug" Nose* — Don't light from below; this will accentuate the very obvious nostrils that are typical of this nose shape.

The *best way* to learn how to paint a nose is to *study your own.* Look in a mirror and notice these factors about your nose, which, you'll find, are the same factors found in all "nosedom":

(1) The deepest indentation is higher than the pits of the eyes. (2) The nostrils' widths line up with the pits of the eyes. (3) Feel your nose. Find the end of the nose bone. Then wiggle the end of your nose. You'll then see why the front plane of the nose *can't* be painted in *one long stroke,* as almost every student will do. It should be painted in *two strokes* —

one for *the bone area,* one for *the flesh area.* (4) So often people paint noses that look flat because they're not observing that the nostrils are on the *underplane* of the nose. Prove this by putting your finger at the very end of your nose and then feeling how far in your fingers have to go to feel where the nostrils are placed. You'll find that the nostrils always have to be placed in a *shadowed area* since the light's coming from above.

NOW, LET'S PAINT NOSES :

STEP 1. *Mass in* with flesh color (refer to Fair Skin, page 86; Ruddy Skin, page 88; or Flesh Tones of Dark-Skinned People, page 87).

STEP 2. Use a gray-green, gray-blue or gray-violet for wherever you *don't* see the nose in illumination. This light and dark contrast should shape the nose as you see it.

STEP 3. Add the *highlights* that you see on the bone section, the end section, the nostril area and the slope where the nose blends into the cheek.

STEP 4. Return the color back into the shadow. Again, refer to the flesh *Color Recipes.*

STEP 5. Add some darker, cooler color to the mixture, such as a little Alizarin Crimson and Ivory Black to show the *cast shadow* of the nose on the cheek. Add a touch of Indian Red to this color for the nostrils.

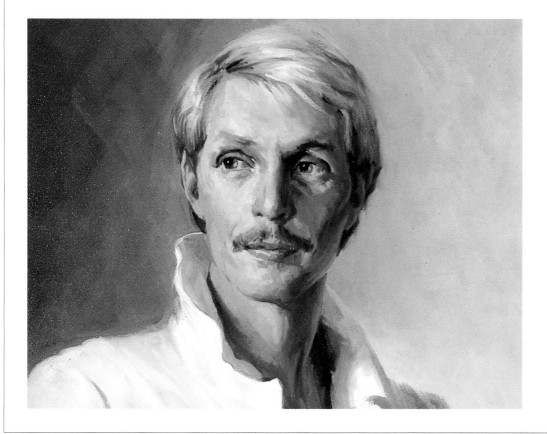

Painting Children

It's very tempting to try one's hand at painting children.

WARNING! It's harder to paint a portrait of a member of your own family than to paint a stranger. The reason — you want the *results of the doing* rather than being intrigued with the *actual doing*. This preconceived idea of the way you want the picture to be inhibits the painting process. If you *ARE* lured into painting a child in your family, don't be afraid. In painting you always have a 50-50 chance — *a mess or a masterpiece!!*

Since children can't pose for any length of time, it's easier to work from a good photograph. *No flash pictures!* The flat lighting never gives you the contrasts of tone you must record to make an image appear on a flat surface. Don't try to paint a picture of the child smiling broadly or laughing, as cute as you and the family think this may be. This spontaneous flash of expression is for photographers, not portrait painters.

Have an 8 x 10" enlargement made of the photo you choose to work from. The job's hard enough without straining your eyesight.

THE PAINTING PROCESS:

STEP 1. It would be best if you try to paint loosely. This would better record the spirit of youth. There's nothing deadlier than an overworked portrait of a child. The loose look is easier to do on a toned canvas instead of starting with a white surface.

STEP 2. Tone the canvas with a wash of Burnt Umber, white and either Ivory Black or Green Earth. If you're using oil colors, mix with turpentine; if you're using acrylics, mix with water. Make this wash in a coffee cup and apply it to the canvas with a rag that's been dipped into the mixture. The tone of the wash on the canvas should be the value of #4 on the VALUE SCALE. Or it should look like the color of coffee with a lot of milk in it.

STEP 3. Place the head size on the canvas and paint in all the shadows and the hair with gray made of Ivory Black, white and Burnt Umber.

STEP 4. For flesh mixtures, refer to Fair Skin, page 86.

STEP 5. *A looser effect is easier to get by using large brushes.* I suggest Sizes 10 and 14 red sable Bright or their equivalents in Overture. By using just these two brushes the texture of the paint will be consistent and the picture of the little face will hold together and be a likeness instead of a record of eyes, nose and mouth.

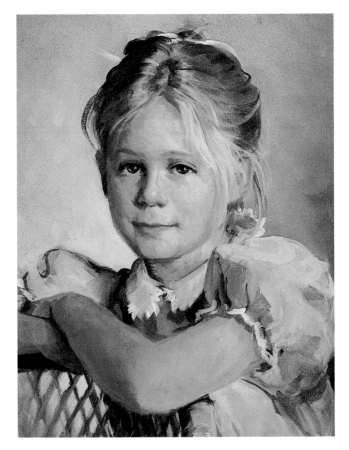

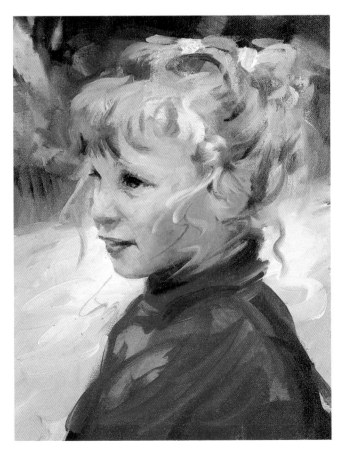

Self Portrait

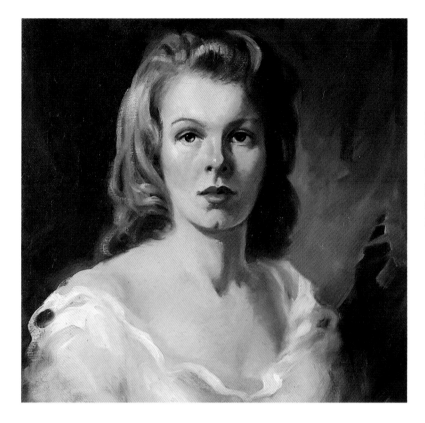

I painted this self portrait while I was still under the tutelage of M. A. Rasko. I was 18 at the time and appreciated the small amount of improvements he made: First, that Rasko felt that the portrait required so few changes, second, to be able to have his very own strokes on my work. It's signed H. DeBoer, my maiden name.

I can't recommend a better way to study portraiture than to use yourself as a model. Not only because you're available and patient but you have a chance to study alone without the influence of another personality in your studio. Anyone who paints a portrait, unconsciously wants to please the model; this can inhibit your painting style. Oddly enough, it doesn't seem to happen when you're trying to paint yourself.

Another reason why a self portrait's a good experience is that your easel, your pose and your mirror will *force you to paint with your canvas in shadow.* Because you'll have to position yourself to have the light shine on your face, your canvas will then be away from the light. Why should your canvas be in shadow? Rather than seeing the paint itself you'll see the tones of the paint and how the contrasts create form.

STEP 1. Set a mirror up in such a way to see yourself. Put it in the place where a model stand would be.

STEP 2. *Don't try to paint and look at yourself at the same time.* Look and then paint! Look and then paint! Just as you would do with a model. If you don't do this your portrait will have that "peeking-out-of-the-corner of-the-eye" look.

STEP 3. Take a ruler and measure the size of your head. Put that measurement on the canvas. Hold a ruler or brush up against your nose, then make marks on the ruler or brush where you see the mouthline, nose, eyeline, eyebrow line and hairline. Transfer these proportions to the head size on your canvas to give you the beginning of your drawing.

STEP 4. Do the same thing with the brush or ruler held horizontally. This will give you the proportions of the side hairline, eyes, corners of the mouth, width of nostrils, etc. Once these marks are set down on your canvas they become guideposts for your shadow pattern.

STEP 5. Squint at yourself to see the shape of the shadow that travels down your face from your forehead to your chin. It forms the sockets of the eyes, the shape of the nose, the shape of the upper lip, the shape of the lower lip, the chin, and it continues down your neck. Paint this entire shadow in one tone of gray by mixing Ivory Black and white and a little Yellow Ochre.

STEP 6. Now mass in the flesh color wherever you see the light striking your face. Then mass in the hair tone, the background and the clothing.

IMPORTANT: The shapes of the shadow pattern, the flesh pattern, the silhouette of the hair are all most important. Also important is the application of paint; it should cover the canvas well. Beginners make the mistake of thinking that the initial coat of paint has to be thin. A painting develops by making *additions* to the already well painted areas and *not* by repainting the entire area.

Plaid

STEP 1. With the lightest color that you see in the plaid, paint the entire garment — with all its lights and darks — to its completion. Let this dry.

STEP 2. Now, using Grumbacher Painting Medium II, or a medium that you can make yourself of equal parts of turpentine and linseed oil, apply the darker colors of the plaid by mixing the colors that you see with the medium. *This thin mixture of paint is called a glaze.* As it's applied, all the values underneath will show through. By glazing the colors over the dried painting of the garment, you can get the plaid effect very easily. It's a way to make a very realistic interpretation.

For a freer, more loose interpretation of a plaid: Again, paint the garment in its lightest color. While this paint is still wet, stroke in the darker plaid colors in all the areas that are in the light. Then, with darker tones of these colors, suggest the plaid in the shadows, making your strokes go in the direction that the fold's digging in.

No matter which method you use, make the plaid effect carefully around the neckline and shoulders, and just suggest the plaid as it comes near the edges of the canvas.

REMEMBER: *Painting is trickery.* A garment will *look* like plaid if portions of it are very plaid-like up against other portions that are mere *suggestions* of plaid. If you try for a very realistic or photographic effect, you'll invite close scrutiny and criticism because you'll be provoking an attitude of absolute correctness. It's better, therefore, to just suggest subject matter with your paint.

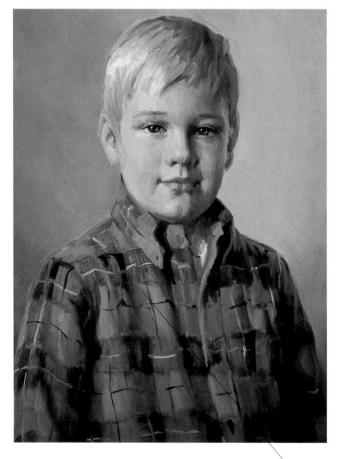

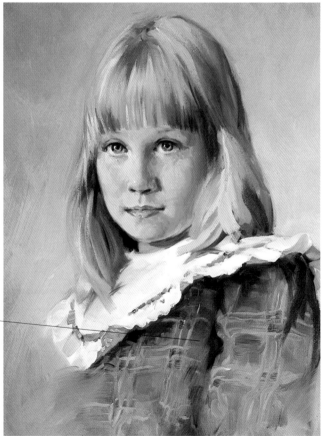

The plaid in the young man's shirt is done in more detail than the young lady's because the painting of his portrait is tighter. All the elements of your picture have to be consistent: if loosely painted, then everything has to be painted loosely. The same holds true, therefore, for tightly painted portraits.

White Shirt

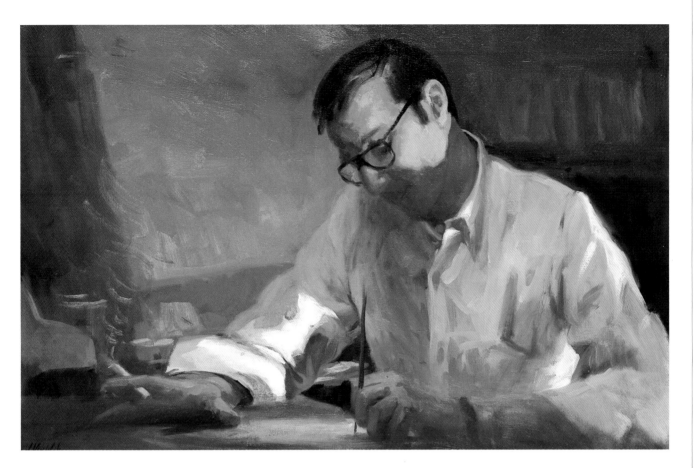

So often the student makes the mistake of painting a white shirt of a man's portrait *too white*. For one thing, this can make the shirt jump out and look flat. For another, the white shirt won't look illuminated if it's painted without color.

Herewith, the mixtures to put a white shirt in its proper place:

STEP 1. Mix white, a little Ivory Black, and a little Burnt Umber to achieve a slightly warm light gray, and paint this color wherever you see light on the shirt.

STEP 2. Mix more Ivory Black along with a bit of Alizarin Crimson into that mixture to get a darker gray. Use it to paint in the shadowed areas.

STEP 3. Mix white with a little Yellow Ochre and lighten the light areas. If you apply this mixture over your already light areas with a large flat brush so that the color drags over the already applied mixture, these two colors in juxtaposition make the paint look like fabric rather than making it look like just paint.

STEP 4. Mix a little bit of white and Raw Sienna into your shadow mixture and apply this warmer gray into the shadows on the shirt. The shadows will then be illuminated with a reflected light.

Helpful Hint: It's so much easier to make the shirt go around the neck and look like it's behind the coat by extending the neck color deeper into the collar area than it really is. Furthermore, don't have the jacket, sweater, or any other outer clothing painted to completion. **More neck and less coat** gives you the chance to cut the collar color up to the neck and to wrap the coat color around the shirt. The tie, of course, is painted **after** the shirt has been done. Although this seems so very basic, many people don't follow this simple procedure because they're in the habit of painting all the darks first rather than starting with those areas that are farthest back.

Skin Tones

BASIC FLESH COLOR:

Put Yellow Ochre and Cadmium Red Light into a lot of White. Wherever the face gets redder — such as the cheek area, the chin and the nose — add Light Red or Alizarin Crimson to the mixture. To get duller colors, add Burnt Umber to this body tone.

HIGHLIGHT:

Into a lot of white add Cadmium Yellow Light and Alizarin Crimson.

SHADOWED FLESH:

Mix a gray (Ivory Black and White) that's darker than the basic flesh color, and then add Yellow Ochre and Cadmium Red Light. If this mixture has to be grayer, add a touch of Viridian.

TIP 1. Don't make your flesh color so light that your highlight won't show up as a light value on it.

TIP 2. When mixing flesh, always *start with white by* pulling some down into your mixing area. Then add the other colors into it.

TIP 3. Don't be stingy about your flesh mixture. Start with a mounded teaspoon of white.

Olive skin is a little darker and more muted than fair skin. To control all the colors that you see in olive skin, mix up a puddle of white, Thalo Yellow Green, and Burnt Umber. This mixture has to be very light, about the color of a pearl. *Use this puddle on your palette instead of white to lighten your flesh colors.*

OBSERVATION: Olive skin is unlike ruddy skin since it doesn't seem to have as much variation of color. But, strangely enough, whenever you know you want a smooth-blended effect, you have to initially lay in your colors with a lot of vitality in order to have this application withstand the blending process that will follow.

For fair skin, Yellow Ochre and Cadmium Red Light into a lot of white; shadow it with a gray, Yellow Ochre and Cadmium Red Light, and highlight with Cadmium Yellow Light and Alizarin Crimson into a large gob of white.

For Olive skin, white, Thalo Yellow Green and Burnt Umber.

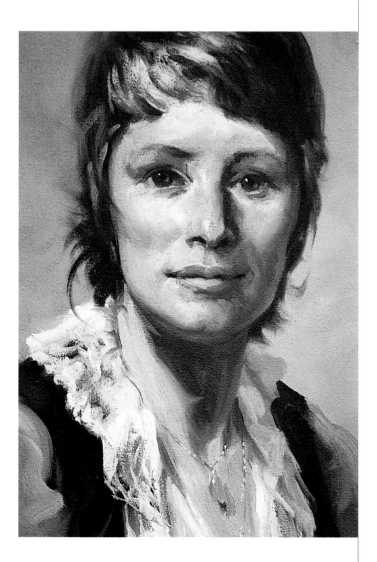

Skin Tones

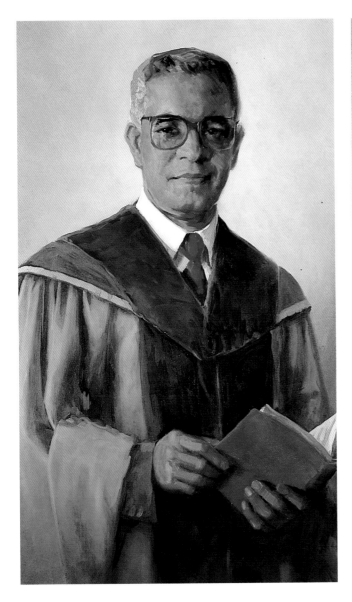

Since flesh color (as it's commonly referred to in painting) is any warm color into white, darker flesh tones are made of any warm color into *darkened* white. To paint dark-toned flesh, start out with a puddle of darkened white.

Make this darkened white puddle by mixing Burnt Umber and Burnt Sienna into white. Then tone it down with a little Manganese Violet or Cobalt Blue. The value of this darkened white should be about #4 on the VALUE SCALE.

Use this as a puddle to add all the colors that you see on the face, such as Burnt Umber, Yellow Ochre, and Alizarin Crimson for the *forehead; some Indian Red or Venetian Red in the middle face area;* and, of course, add Alizarin Crimson and Thalo Blue to this to make the *shadows.*

For the *highlights,* add white to this mixture with some Cerulean Blue or Manganese Violet. The contrast of the highlight color on dark skin is *greater* than on fair skin. Make sure these highlights are *cool gray,* not a mixture of Burnt Sienna and white, or Cadmium Yellow Light and white.

The biggest mistake I've seen in beginners' and students' paintings of dark skin is the failure of the painters to see the illumination in the dark skin, thereby neglecting to get a contrast of lighted dark skin and shadowed dark skin.

Another glaring error — the whites of the eyes are often painted too light. They only look that light in contrast to the dark skin. To make whites of eyes that look right, add a light gray (Ivory Black and white) to the darkened white.

Skin Tones

You'll find many variations in the skin color of a ruddy-complexioned person. The ruddiness isn't an even color from forehead to chin, thereby presenting a problem of painting many mixtures of flesh in juxtaposition, so all the little different hues of reddish orange will work together to present the appearance of this type of complexion.

It's interesting to note that people with this type of skin color also have what you can call *"ruddy personalities,"* which is fortunate for the artist. Your portrait presentation doesn't have to be smooth and blended, but painted in a craggy way *to interpret the personality as well as the skin.*

A common mistake in painting the skin is to rely on Burnt Sienna, which would appear to be the right choice. It shouldn't be used in excess, however, because it's too dull an intensity, whereas ruddy skin is bright. The bright oranges and the reds, therefore, should be the ones to rely on.

HERE'S ONE WAY TO PAINT RUDDY SKIN:

STEP 1. Mix Raw Sienna, Venetian or Light Red, and some white, and tone this mixture down with Manganese Violet and some Thalo Yellow Green. This mixture should resemble a grayed clay pot. Make sure this mixture isn't too bright nor too light. In fact, it may even need a touch of Ivory Black.

STEP 2. Paint a thin coat of this color over the flesh area. Add Ivory Black and Cadmium Yellow Light to it to make the shadow tone. Paint in the shape of the shadows.

STEP 3. Now you can begin to invest all the colors that you see on the model into this basic mixture (see Fair Skin, page 86). The same mixtures apply, but they'll be affected by the basic ruddy tone.

STEP 4. Put the highlight on the nose with a mixture of white, Alizarin Crimson, and a little Cadmium Yellow Light. Mix a lot of this highlight puddle so that you can mix into it all the different colors that you see in the middle face area, wherever you see the many little forms of the cheeks' shine or glow.

STEP 5. Now, as you get toward the bearded area — or chin — add a touch of Burnt Umber to your already mixed flesh colors.

I find when painting any type of skin that I need one sitting of painting wet paint into my initial wet beginning. But then to finish up, I like to work on a dry enough surface that I can touch up with glazes of color, such as more red on cheeks, more dull red around the nose area, and a glaze of Burnt Sienna over the shadow pattern. Remember — glazing is applying transparent color that's thinned with a medium.

IMPORTANT: Transparent color can't have any white in it.

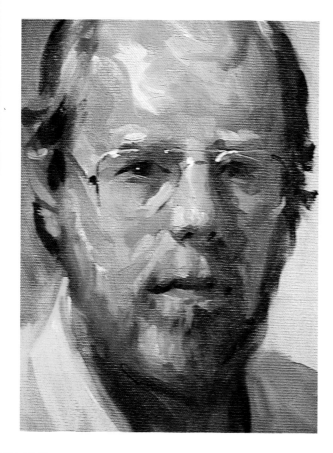

Mix Raw Sienna, Venetian Red and white and tone down with Manganese Violet and Thalo Yellow Green. Add Ivory Black and Cadmium Yellow Light for the shadows.

Teeth

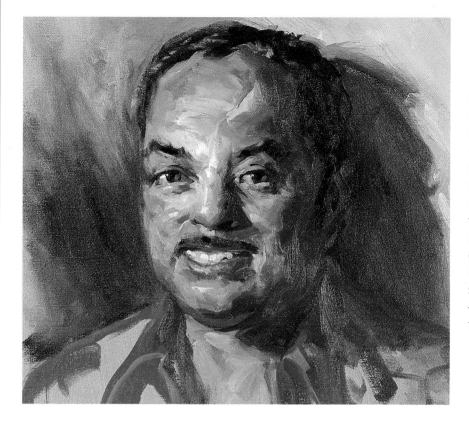

In all of my books on portraiture and in the many articles that I've written on the subject, I've admonished would-be portrait painters never to paint a portrait that shows the model's teeth (except in extraordinary cases). This is a pose for photographers and not well suited to portraiture. So how come I painted this portrait with this pose? The model is my dear friend, Frank Wilbright, who posed for one of my demonstrations when he came to visit me in Rockport. As soon as he sat on the model stand, Frank smiled at me — and the audience — and kept this broad smile throughout the two-hour demonstration.

If you *must* paint teeth because you can't avoid *not* painting them, realize that you're doing something that's very hard in portraiture. On rare occasions, I've had to paint teeth. That's when my model was "bucktoothed" or couldn't help but smile "toothily" as I looked at him or her. Page through reproductions of the works of the "old masters" and count how many portraits show teeth.

There's more of a temptation to paint teeth today because we have photographs to refer to. If you have to paint teeth, keep this caution in mind: *be prepared to have your portrait referred to as "photographic."*

Since a smile is spontaneous, you must organize your procedure of painting it very carefully, and hope that your dexterity is in tip top form as you follow your plan of attack. So — if you *must* paint teeth, here's the right way to do it:

STEP 1. With a gray of value #2 (or a trifle lighter) on the VALUE SCALE (made of Ivory Black, white, and Yellow Ochre), *mass* in the teeth area in an across slash. This painted area should be *larger* than the teeth area really is.

STEP 2. Then, with a gray-violet (made of Ivory Black, white, Alizarin Crimson and a little bit of Burnt Umber), *"shadowize" the teeth* where they're going away from the light.

These shadows are the ones I see on the teeth area when I squint my eyes. They're not the dark spaces between each tooth.

STEP 3. Now, with *upper* lip color (which is *shadowed)* and *lower* lip color (which is light) paint in the upper and lower lips, cutting down the teeth area. (For lip color, refer to " Lips for Men and Women," page 80).

STEP 4. With gray #6 on the VALUE SCALE, plus some Light Red, paint the *shadows* that are caused by the upper lip (this has to be *darker in tone* than the lip).

STEP 5. With a lighter gray, #2 on the VALUE SCALE (very light gray plus a little Burnt Umber), make some vertical strokes to indicate the individual teeth on the light side.

STEP 6. The teeth on the shadow side may need some darker accentuations to show the slight spaces between them.

STEP 7. If this process doesn't work, *wipe it all out* and start the procedure again. *You can't keep working on it.* It'll just get bigger and worse.

Finally, REMEMBER — toothpicks are for picking; paint brushes are for recording correct tone values.

Wrinkles in the Face

Don't paint any wrinkles by painting dark lines in the flesh color with a small brush. You'll end up with your model having deep incisions instead of pleasant character lines. You'll also end up with a model that's unhappy with your rendition.

Realize wrinkles are little dents and can't be made by adding paint because addition of paint makes lumps not dents. Therefore any wrinkled area, such as the forehead, around the eyes, the corners of the mouth, etc, should be massed in with a toned-down flesh color: Green Earth or Burnt Umber into general flesh color (See Fair Skin, page 86).

Then use your *general flesh color* to paint the lumps that appear between the dents, which are the wrinkles.

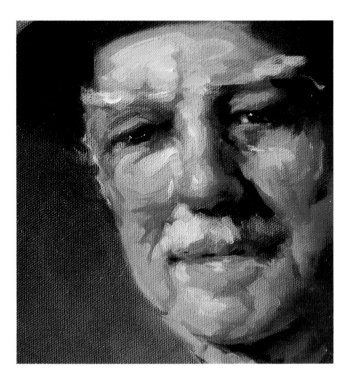

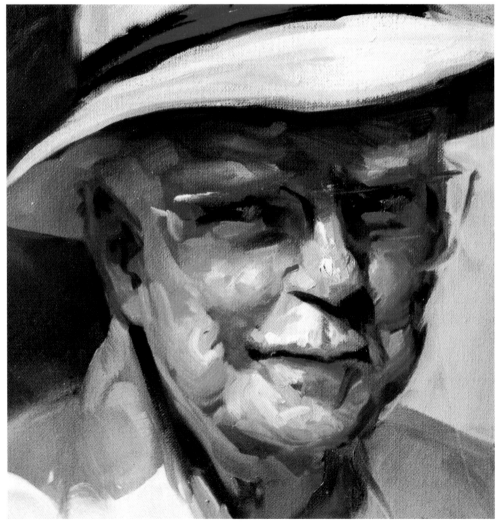

Still Life

The Italians call it *natura morte* (literally, "life that's dead"), we, of course, call it still life. Anyone who is familiar with me, my work, my television show and the way I teach knows that I am primarily a still life painter. My experience with still life has helped me immeasurably with portraits and even landscape. Still life painting is truly the backdoor to good painting.

Still life painting for me has had another plus factor, that being the tremendous amount of still life subjects that I have had to collect; this has meant untold visits to antique shops all over the planet in a constant search for objects to paint. And as much as I loathe shopping for clothes and such, that's how much I love dropping in on antique stores to look for bowls, pitchers, dishes, shawls, porcelain figures, and on and on, to feature in still life compositions. A still life painter has to be a collector. Isn't that fun?

When I first conceived this book of *Color Recipes,* I tried to think of all the things that I like to paint: Vegetables, fruits, decorative metals of all kinds, a variety of wood, glass (transparent, opaque), pottery, china and every sort of fabric. I assumed that other painters would be as enthusiastic as I was. And I was right. My initial *Color Recipes* introduced many readers to still life and they are now faithful converts. I discovered, too, that a great number of artists started using my *Color Recipes* to teach others. The process has continued over the years and is still going strong.

Before you go on to the first *Color Recipe* in this section, I would like to make a suggestion: Try to remodel your thinking about what you paint and why. By that I mean, don't always consider your painting sessions in terms of full compositions. Small studies of individual subjects will give you the much needed practice that will make you more facile with all subject matter.

Basic Brushwork

Since we're trying to paint a three-dimensional effect on a two-dimensional surface, it seems logical to move the paint in more than one direction. Painting onions is a good example of this maneuver. Here's the procedure:

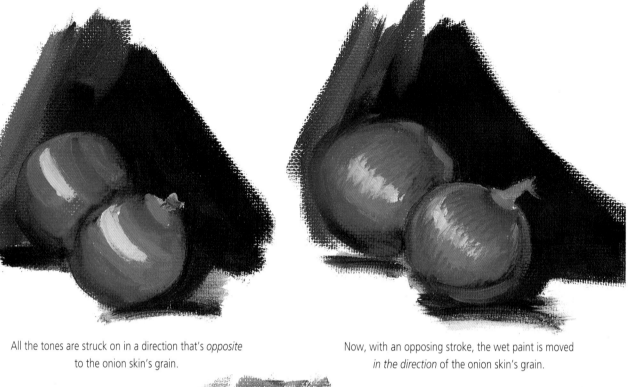

All the tones are struck on in a direction that's *opposite* to the onion skin's grain.

Now, with an opposing stroke, the wet paint is moved *in the direction* of the onion skin's grain.

Repeat the same procedure to now make the outer skin. Then, finish everything off with lighter lights and darker darks to pull the effect into focus.

Red Apples

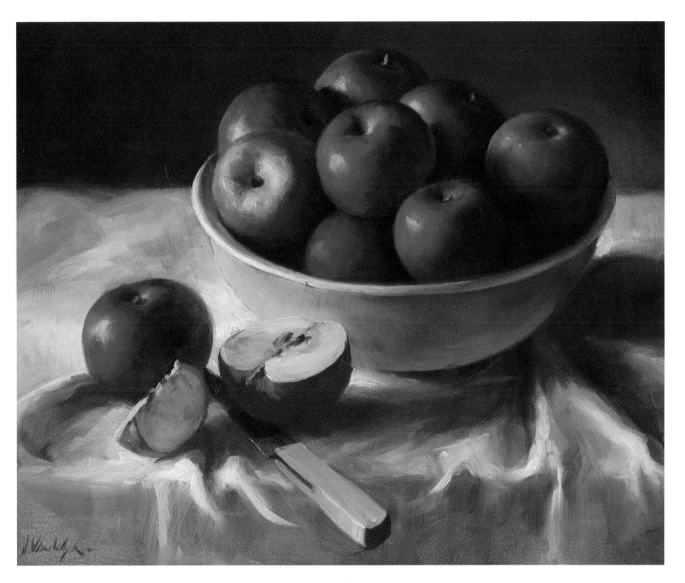

Progression of application is very important. Make your more dominant color overtake the more delicate one.

After drawing the shape of the apple, splotch in the yellow-green areas *larger* than you really see with a mixture of white, Cadmium Yellow Light, Yellow Ochre, and a little bit of Thalo Green or Viridian. Adjust the hue to tend towards yellow or green as you see it.

Now, with a general mass tone of Alizarin Crimson mixed with Grumbacher Red, mass in the shape of the red apple, fusing this mixture into the yellowish green splotches already on your canvas.

Body Shadow: Add more Alizarin Crimson to the body tone mixture, adding a breath of Thalo Yellow Green to it.

For any *waxy shine* you may see, use Ivory Black, white, and Thalo Green. This is best applied when the red mass tone has *dried slightly.*

Now, with Thalo Green into a lot of white, put a highlight on the planes that are directly in line with the light. If this highlight looks too sharp, work around it with Grumbacher Red mixed with a little white.

HERE'S A NO NO!!

Never put a highlight in the *middle* of an object even if you see it there. It divides the object and indicates that the light is coming from your point of observation. This light source is impossible to use if you want to get a dimensional effect. *Shadows and highlights are your main means to record depth.*

Barrels

Painters encounter barrels on docks by the sea or in and near barns in the country. They also find a variety of buckets that store food and drink. Barrels and buckets are cylinders, which is one of the five basic shapes.

Here are the most important factors or planes to be aware of when painting any cylindrical object:

1. Its *thickness,* described by the *upper ellipse.*

2. The *down* plane that's toward the *light.*

3. The *down* plane that's *shadowed.*

4. The *highlight* that hits the edges *between* the top plane and the side plane at the spot where the light strikes directly.

5. Any peculiarity, such as *wire bands* and *wooden hoops,* should be painted onto the constructed cylinder in tones that are *light where the light strikes* and *dark where it's in shadow.*

Now for the color of barrels and buckets: Make your illuminated area out of gray #4 on the VALUE SCALE plus the particular kind of barrel or bucket color you're involved with. For instance — a *rusty barrel* would be gray #4 with Venetian Red; an *oak bucket* would be gray #4 with Burnt Umber; a *weathered barrel* would be gray #4 with Raw Umber.

The *shadows* are a darker gray (#8 on the VALUE SCALE) with more of the color used in the light side color. For

Helpful Hint: If you want a lighter brown, add white. Don't add a lighter color.

instance —more Venetian Red or more Burnt or Raw Umber. Add to this color Alizarin Crimson or any dark violet.

The highlights or shine: Gray (#2 on the VALUE SCALE) with Manganese Violet or a little Alizarin Crimson.

The *biggest mistake* in painting barrels and buckets is to make them *too bright* and you falsely see the lighter tones as brighter colors rather than as lighter tones of *its original color.*

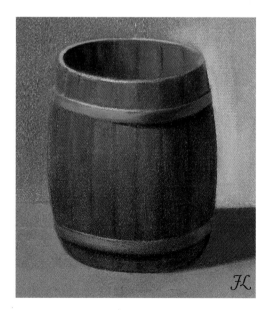

Baskets

The trick in painting baskets is to ignore the weaving in your initial lay-in of paint. Mass in these colors in just *flat tones*.

FOR A GENERAL MIXTURE:

Use Raw Sienna, Yellow Ochre, some white, and even some Burnt Sienna added.

Don't make this mixture too light! In fact, *it shouldn't even look like the basket tone;* it should be two shades darker than what you see.

FOR THE SHADOWED AREAS:

Add a little Ivory Black, Alizarin Crimson, and a touch of Burnt Umber into the basic tone. This application of paint *should cover the canvas well,* but it *shouldn't be thick.*

TO ADD THE WEAVING EFFECT:

Start out by putting in lines of Burnt Umber that show the vertical spokes that the fibers are woven in and out on. Sometimes these spokes show up quite light. If they are, use Yellow Ochre, Raw Sienna, and white. These must be the beginning of your "weaving" process because this was how the basket's weaver began *his* process.

Now, with the actual color of the basket, which is lighter than the mass tone — often a mixture of white, Yellow Ochre, and even a little Cadmium Yellow Light (if it's yellow) or some Cadmium Orange (if it's more toasty looking) — strike little strokes one under the other (all of them over one of the vertical spokes) leaving spaces between each one.

Over the next spoke make the same kinds of little horizontal strokes, but have them interlock the strokes you made on the first spoke. This will make the fiber look like it was woven over and under the vertical spokes because on the third spoke your strokes will line up with those on the first, and on the fourth spoke they'll line up with those on the second, and so on.

Naturally, *on the shadow side,* a *darker mixture* has to be used to show the weave. This could be the same as your light side mixture, but with less white in it.

Remember: you can't turn a white canvas into a wicker basket. However, you can impart a woven effect to an already painted-in area that's the shape of a basket. *Always establish the form, then add the texture.*

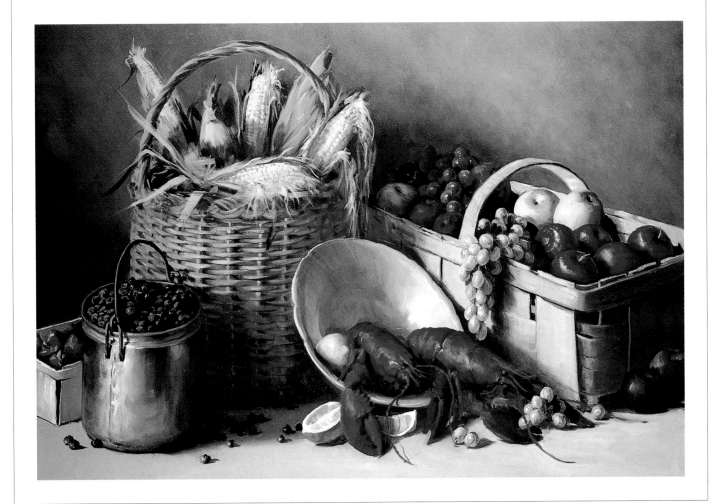

Opened Book

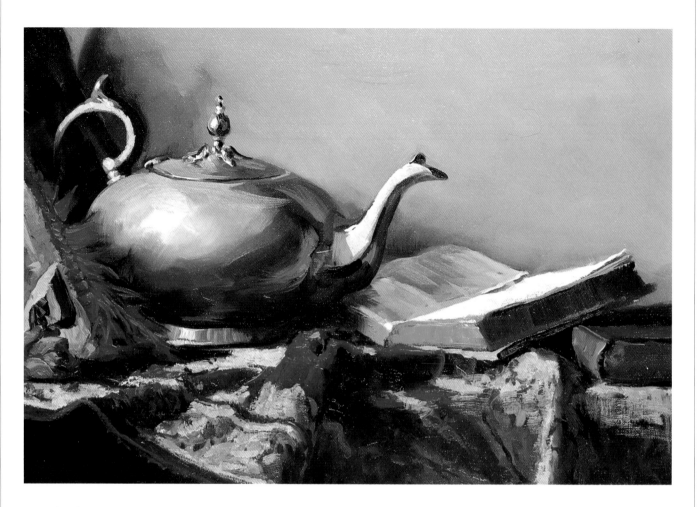

Open books are perfect for many still life arrangements. They tend to fill up empty spaces and add interest even to the foregrounds of flower pictures.

STEP 1. Avoid making the open book look like it's running uphill. Do this by first judging how high the shape is in relation to the width.

REMEMBER: perspective changes the sizes of things. Getting the right proportion is the key to the right perspective.

STEP 2. Draw the book by actually constructing a box.

STEP 3. Start painting the book by stroking from the top of the page, pulling your strokes forward. Use a very light gray of Ivory Black, white and a little Yellow Ochre. Paint the page blank. *Leave the printing out!* You can always add the appearance of printing last.

STEP 4. Now, with down strokes, paint the side planes of the pages — the light side and the dark side. The side plane toward the light is Ivory Black and white with Burnt Umber, Raw Sienna or Yellow Ochre.

If the pages of the book *are edged with gold,* use Raw Sienna,

Yellow Ochre, and a little white. You'll later *highlight* with white, a touch of Yellow Ochre, and some Cadmium Yellow Light. *Paint the highlight with a stroke that's opposite to the downward stroke.*

For pages edged with red, use Cadmium Red Light into very light gray. The shadow side of these edges are darker tones than the light side, and can be made by adding Ivory Black and Alizarin Crimson to the colorless edging. The same mixture can be added to the shadow side of the gold-edged pages because you're adding the mixture into a different mass tone. For the shadow side of the red-edged pages, add more Cadmium Red Light, Grumbacher Red and Chromium Oxide Green into your light side mixture.

STEP 5. Paint the cover color that you see as it meets the table.

FINALLY: Accentuate the open pages with Yellow Ochre and lots of white. It's with this mixture that you can lighten the margins of the pages, thus leaving the mass tone to suggest the printing on the pages.

Green Bottles

The color of a green bottle depends on its background. It can *only* be light and bright against a light background. When you see a green bottle against a *dark* background, you can only see little spots of light, bright colors.

STEP 1. *Mass in the green bottle* with a tone of green that depends upon the background: *If against a dark background* — Thalo Green, Burnt Sienna, and Burnt Umber. *If against a light background* — Thalo Green, Burnt Sienna, and Cadmium Yellow Light.

Don't ever paint down one side of the bottle and then down the other; you'll never get them the same. And in the process, the bottle will grow progressively fatter, Instead, paint a green line down the center of the bottle and then mass in the green from the inside of the bottle shape *out to the edge* in sections starting from the top. One section is the top ellipse; the next, the thicker glass at the top; the next section is the neck; then the section that flares out; and then the section that's the main bulk of the bottle.

STEP 2. With a bright green (either Thalo Yellow Green pure or a mixture of Thalo Green, Cadmium Yellow Light, and white) add any of the bright spots that you see.

STEP 3. Put a little Alizarin Crimson into Thalo Green and paint any of the dark spots that you see. They're usually found around the ellipses at the top, at the base, and, oddly enough, down the edge of the bottle that's *toward the light source.*

STEP 4. **The highlights:** White with a touch of Alizarin Crimson.

STEP 5. **Gray haze on the bottle:** Ivory Black, white, Alizarin Crimson into a little of the basic green tone, making a tone that's lighter than the basic tone.

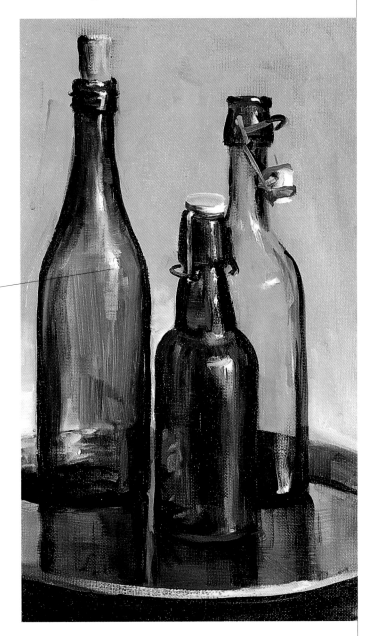

Highlights are all important when painting glass bottles to help you get the shiny look. You never want to use pure white in a highlight, which is made of a lot of white and a smidgen of the color that's complementary to the one on which the highlight is to be applied. In the case of the green bottles, you'll need to add a very little bit of Alizarin Crimson, the complement to the green of the bottles. How do you apply a highlight? You'll find the procedure on page 103, Dew Drops.

Chianti Bottles

STEP 1. Mass in the glass part of the bottle with a basic green tone that's not the lightest nor the darkest tone of the bottle. The mixture: Thalo Green, Yellow Ochre, and some white. If it's too light, add a little Ivory Black or tone it down with a little bit of Burnt Sienna. (Viridian may be used instead of Thalo Green, but you'll have to use *three times as much.)*

STEP 2. Mix Thalo Green with a little Alizarin Crimson and paint in the darks on the glass. You can do this more easily if you *start from the top and work down.* See the top ellipse, the darkness of the thicker glass, and the dark caused by the wicker that's wrapped around the back of the glass.

STEP 3. Mix some Cadmium Yellow Light and a little white into the basic tone, or just add Thalo Yellow Green. Then, starting again from the top, search out and paint all the little lighter spots. Press this mixture into the already wet paint so it blends into the mass tone.

STEP 4. With Alizarin Crimson into a lot of white, paint the highlight on the back part of the upper ellipse, the front part of the ellipse, on the concave part before it bulges, and pull that highlight over the dark caused by the wicker on the back of the bottle, all the way down to the yet unpainted wicker area. Paint all the labels onto the glass. Wipe away, first, some of the wet green paint with a rag.

STEP 5. For the wicker: mix Raw Sienna and some white with a little Burnt Umber, and mass in the wicker area. *Don't make this mass tone too light by using too much white.*

STEP 6. Into this add a little Cobalt Violet and darken the side of the bottle that's in shadow. This mass tone and shadowed area shouldn't be painted with strokes that show the wicker. This is better done with these additional values: *for the lights on the wicker,* mix Yellow Ochre and white. Load the brush and stroke it over the mass tone in downward strokes to show the bands of straw. *Don't use this mixture on the shadow side.*

Where the bottle bulges very much toward the light, a lighter version of this mixture can be used by adding more white and a little Cadmium Yellow Light.

On the shadow side, strike in bands over the violet shadows with Raw Sienna, and finally, where you see the few very dark lines that are accentuations, use Burnt Umber.

The twisted little string can be added last by using the Yellow Ochre-and-white mixture. It can be shadowed with the shadow color.

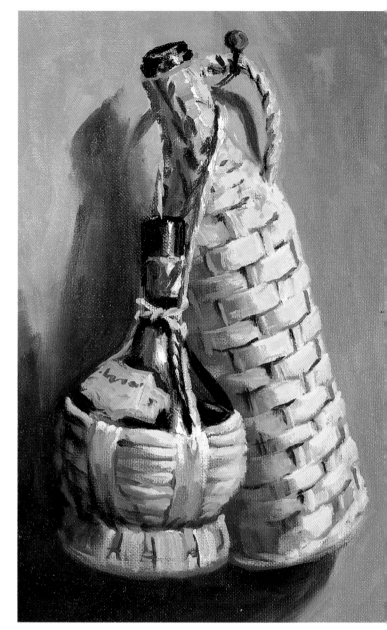

I don't know about art schools these days, but when I was a student, every art school studio that I'd ever been to had wicker-covered chianti bottles in evidence. This subject matter represents a challenge for an artist (and especially for students), with its combination of textures, hence the contradiction of reflective texture (glass) with nonreflective (wicker).

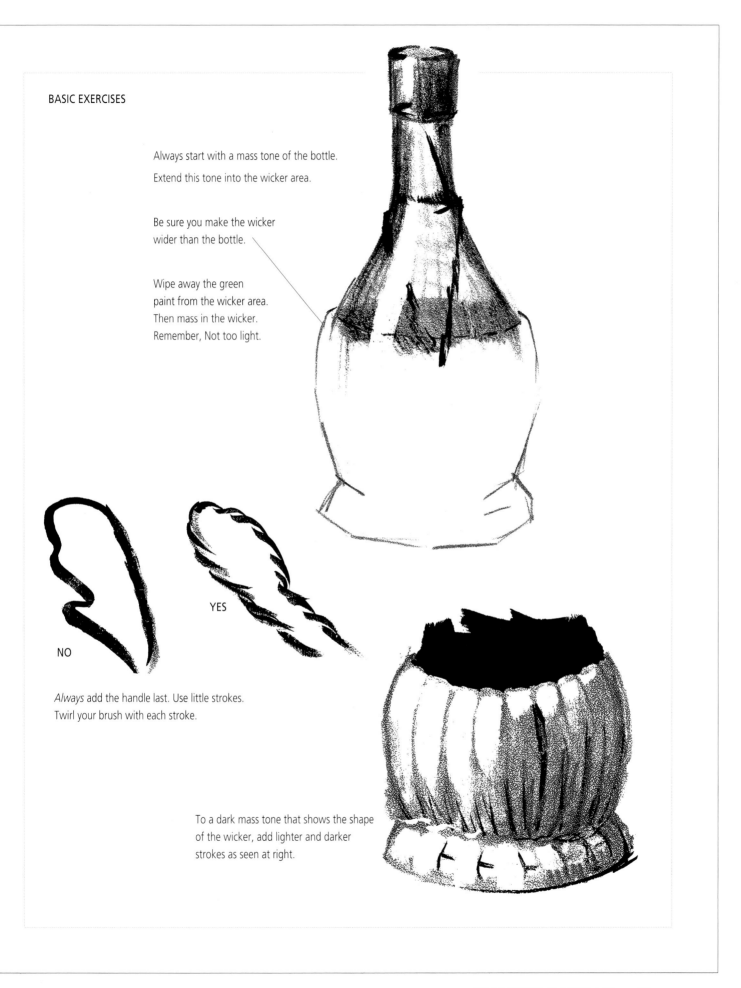

BASIC EXERCISES

Always start with a mass tone of the bottle.
Extend this tone into the wicker area.

Be sure you make the wicker
wider than the bottle.

Wipe away the green
paint from the wicker area.
Then mass in the wicker.
Remember, Not too light.

NO

YES

Always add the handle last. Use little strokes.
Twirl your brush with each stroke.

To a dark mass tone that shows the shape
of the wicker, add lighter and darker
strokes as seen at right.

Brass

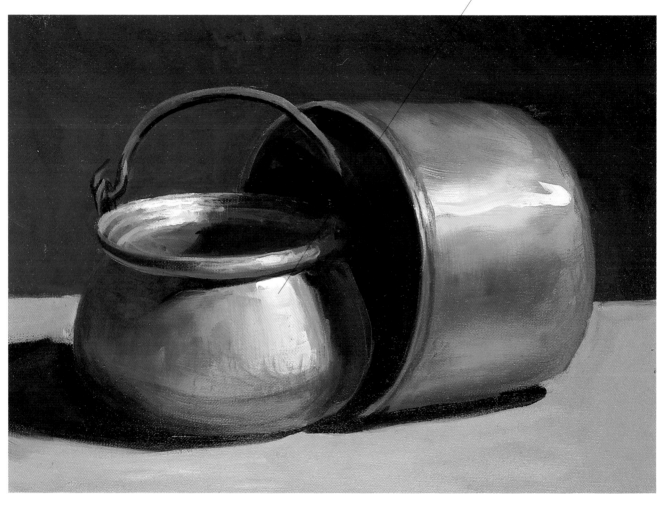

In still life no other texture can help you add an accent than some object made of brass: an ash tray, candlesticks, a teapot, a tray, to name a few.

The whole trick to painting brass successfully is to be able to show its shiny quality. *Anything that shines can be recorded by putting a very light tone against a dark tone.*

Consider Cadmium Yellow Light and white as the lightest yellow you can mix. If this mixture is used for the shiny parts of brass, it can't be used as a mass tone. It must accent a basic brass tone that's *darker* than itself.

Brass is a funny greenish-yellow color. To produce the basic brassy color that's dark enough to accommodate the Cadmium Yellow Light and white for highlights, mix Cadmium Yellow Light or Cadmium Yellow Medium into Burnt Umber.

Where your brass object falls into shadow, add a little Ivory Black, Alizarin Crimson, add a little Thalo Blue into the basic mixture. *For the darkest accents,* you can use Burnt Umber right out of the tube. For reflections caused by other colors around the object, add the reflective color into the basic tone.

China

A good many types of decorated pottery are basically white with the colored decorations added onto them. When painting decorated pottery, always mass in its shape in the *color of the pottery before it was decorated.* Here are a few color mixtures: Ivory Black and white, a little Yellow Ochre and Cerulean Blue to make an off-white for Delft; gray with Light Red (English Red) and Raw Sienna for many types of Mexican pottery; black and white and Payne's Gray for beer steins and pottery that's made of the same material.

Not only should the *basic* color be massed in before the decoration is added, but the pottery piece should be dimensionalized by painting the *shadow* side, putting a mixture of Ivory Black and Alizarin Crimson into the basic tone.

Painting decorated pottery in oils can be compared to painting a watercolor on an already dimensionally painted pot or vase. To interpret the decoration very carefully, let the initial painting of the pottery dry. Then, add all the colored decorations to it with *glazes of color.* This means thinning the colors of the decoration with a medium to a degree that will make *a transparent application.* You know, of course, that *no white can be added to your color* if you intend to glaze with it.

On Delft: Wherever you see the lighter tones of blue, thin Payne's Gray mixed with Thalo Blue with quite a bit of medium so when applied, the white basic tone becomes slightly tinted. Now, where the darker colors of blue appear, don't thin this mixture as much.

For a looser interpretation, mass in the pottery with the lightest color that you see, then add the colors that are darker than the lightest until you come to the darkest one last.

IMPORTANT: Any china or pottery that shines has to be painted in values dark enough to finally be able to put a *highlight* on. The highlight, as you know, has to show *lighter* than the basic tone.

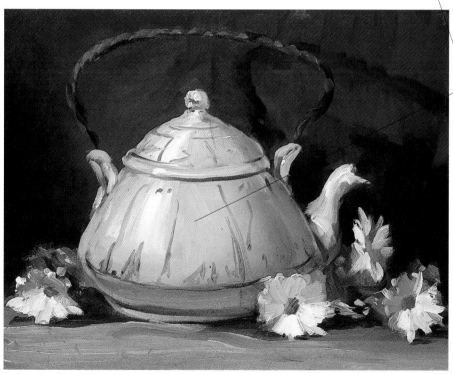

The Dutch cocoa pot in the painting at left was an easier shape to paint than the vase in the painting above. The shape of the pot eased for me the perfection I couldn't escape in the vase's shape. Furthermore, the Delft design on the pot was a snap compared to the high shine of the vase with the additional involvement of recording the reflections of the little ginger pot.

Copper Pots

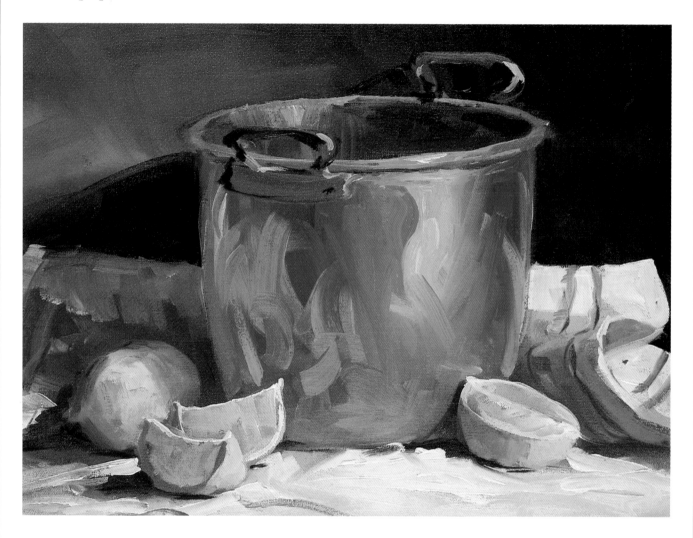

Before I tell you about painting the *color* of copper, I want to give you this important hint on *procedure:* After you've drawn in the pot and are ready to paint it, *don't paint the handles until your background is finished.*

Now, Let's Talk Color:

 Mass Tone: Burnt Sienna, a little white, Cadmium Red Light, and, if the copper pot is tarnished, add a breath of Thalo Blue.

 The Highlight: Take a glob of white and mix into it some Cadmium Red Light and a little Cadmium Orange. *Don't mix these thoroughly.* Load the brush and pile the highlight on *bigger* than it really is. Now, wipe your brush and in the corner of this highlight mixture, add some more Cadmium Red Light and Burnt Sienna, and *ease* the highlight color into the mass tone on your canvas. This highlight should be only where the pot's in direct line with the light. All other light shiny spots in

the copper are *reflections* and can be mixed by adding the particular reflection color into the darkened highlight mixture. For instance, if there's a yellow pear nearby, put Yellow Ochre into your highlight puddle. And if a light background's reflecting in the pot, add some Indian Red to the mixture.

 Where you see *shadows* on the pot, use Burnt Sienna with a little Thalo Blue. And for any very dark orange areas, use Alizarin Crimson and Burnt Umber with a little bit of Burnt Sienna.

 For extremely dark tones, add a little Thalo Blue into this dark orange mixture. After the body of the pot is painted, and the background is done, paint the handle and the spout of the pot.

 IMPORTANT: The color mixture in this recipe can be used to paint *any* copper object, only the shape has to be changed.

Dew Drops

Any painting that has dew drops on a table, fruit or flowers is automatically labeled a "dew drop" painting. Everyone wants to paint them.

WARNING!! Since the dew drops are going to attract so much attention, they'd better be painted beautifully and subtly.

STEP 1. The easiest way to paint a dew drop is to apply it on an already dried area.

STEP 2. Since it has hardly any mass tone (it's colorless), a dew drop is formed mostly by a *highlight, a reflection and a cast shadow.*

STEP 3. With a tiny round brush, take a touch of white and put a spot where you want the highlight on the dew drop. Don't record the entire dew drop, only the highlight on it.

STEP 4. Wipe the paint off the brush and with the brush dry, spread the one side of the highlight. This side should be the one *away* from the light.

STEP 5. With black and white and a little of the color that the dew drop rests on, paint a little half-moon reflection on the shadow side to represent the shape of the dew drop.

STEP 6. Now, with a darkened version of the color that the dew drop is on, paint a shadow on the underside of the dew drop.

STEP 7. If your dew drop looks funny or too obvious, *wipe it off and repeat the procedure.* Don't continue picking around with more strokes and more paint.

Don't record the entire dew drop, only the little highlight on it.

Eggs

Have you ever realized the fascinating pictures you could make with eggs? Their whiteness, combined with a pitcher of milk or white crockery, presents a stark simplicity. And have you ever given any thought to painting egg shells? Or just a bowl of eggs with some others scattered nearby? This is yet another example of how the most ordinary objects found in your kitchen could become subjects for exciting pictures.

Brown eggs, so typical of New England, are, strangely enough, harder to paint than white eggs. Their particular brownness varies, and their shells are less fragile. Moreover, the texture of brown egg shells has a doeskin look rather than the shell-like texture that we associate with white eggs. Enough for brown eggs. Let's show you how to paint white eggs:

STEP 1. *Mass in* the eggs with a value of gray-yellow made with Ivory Black, white and Burnt Sienna to the value of #2 on the VALUE SCALE.

STEP 2. Mix Ivory Black and Alizarin Crimson into this value and paint the shadows in a value of #6 on the VALUE SCALE. Make sure these two tones aren't painted too thickly or too runny because each of these values will have to withstand much painting into.

STEP 3. To the light body tone, add a *lighter version of the mass tone,* using white and Yellow Ochre. Now add the *highlight,* using pure white. (Don't tell anyone you're using pure white. It really should have a little Alizarin Crimson in it, but if pure white *looks* right then *it is* right, no matter what any one may say, even *me,* on page 97, in a caption about highlights.)

STEP 4. Into the shadow add a warm gray *reflected light* by mixing Burnt Sienna, Cadmium Orange and a little white into your shadow mixture.

STEP 5. Of course, the *cast shadows* from the eggs will be complementary to the tone they're resting on. On a white cloth they'd be gray-violet because the white cloth is really a vague yellow. *All light is warm* and the light shines on the cloth, making it a warm color. Reflections on the eggs are dependent upon the surroundings you see them in.

> **Helpful Hint:** Since the study of painting is learning to see the subtleties of nature, we sometimes must do some looking exercises. Set an egg on a black background and right next to it set another egg against a white drape. Notice how different the color and value of each egg is. Now put a raw egg (unopened, of course) next to a hard-boiled one to see the subtle change.

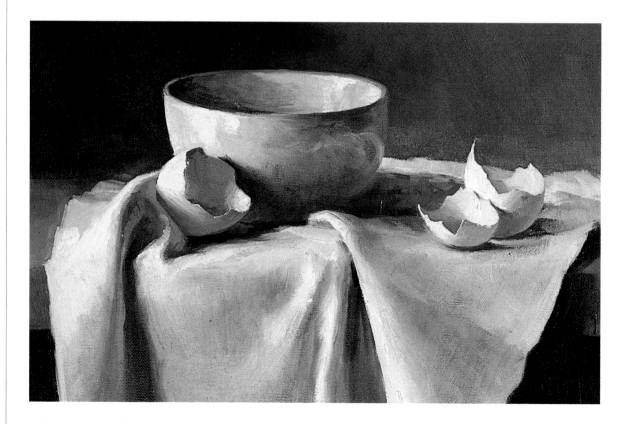

Gold

Gold-decorated china, gold chains, gold watches, etc., can "elegantize" any still life. Here's how you can paint these objects and make them look plausible.

FIRST — it's best to add the gold decoration on the china *after* the china color has dried. You can, of course, paint over it while it's still wet, *but you'll have to be careful not to make any mistakes.*

To start the gold decoration on a dry surface, thin Raw Sienna with a little painting medium (equal parts linseed oil and turpentine) and with the paint now somewhat fluid, draw or paint the gold decoration wherever it appears.

Next, into a big glob of white, add Cadmium Yellow Light and Cadmium Orange. Without thinning the paint, pick up some and lay this very light *highlight tone* wherever you see the gold shine the most. Now, strange as it may seem, you have to add some darker tones. Do this by mixing some Alizarin Crimson and Ivory Black into the Raw Sienna and add any dark areas that you see.

But it doesn't seem strange when you remember that a shine can *only* be achieved by *contrasting a light tone with a dark tone.* The biggest mistake you can make is to mass in the gold too light to begin with.

Next, with some Cadmium Orange and Cadmium Yellow Medium mixed, add the *reflections* that you see. These are bright spots, but they're not as bright as highlights.

IMPORTANT: *Never confuse reflections with highlights.* Reflections are light tones but seem lighter than they are because they're usually in the shadow area. *Reflections are never as light as the highlights.*

When painting something that's solid gold, like a watch, all the above mixtures apply. The *mass tone,* however, will more likely be: a little white, a little Cadmium Yellow Medium, quite a bit of Raw Sienna, and a touch of Burnt Sienna.

Over an offwhite mixture that I used for the pitcher, I applied Raw Sienna thinned with a painting medium for the gold trim. Then, into a glob of white, I mixed some Cadmium Yellow Light and Cadmium Orange for the gold highlights. Finally, for the contrasting darks that are needed to make the gold color look authentic, I mixed Alizarin Crimson and Ivory Black into the Raw Sienna color.

Grapes

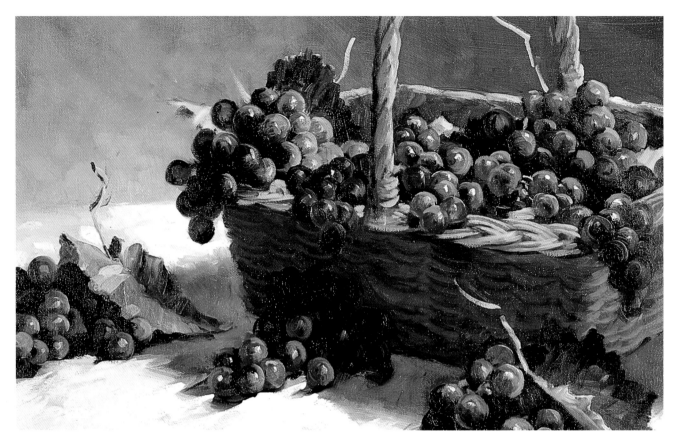

There are many types of grapes. Here are the *mass tones* for all of them:

1. THE BIG DARK BLUE GRAPES THAT LOOK LIKE PLUMS:

Mix Thalo Blue, Alizarin Crimson, and Burnt Umber, and lighten with a little bit of white. These grapes get *reflections that are very gray.* Make this gray with Ivory Black and white (#6 on VALUE SCALE) with a little Burnt Umber. The *highlight* is gray #2 on the VALUE SCALE with a little Burnt Umber. You may have to accent them with a gray-blue reflection or characteristic which is gray #4 on the VALUE SCALE with a little bit of Thalo Blue. Make *shadows* of Thalo Blue, Alizarin Crimson and Ivory Black. CAUTION: Don't make these grapes too colorfully blue or they'll look like clusters of robins' eggs.

2. TOKAY GRAPES:

Mass tone for these grapes: Yellow Ochre with Alizarin Crimson and a little white. Keep this mixture more toward the yellow than the violet. Add more Alizarin Crimson into the mixture only for those grapes that are more reddish violet. Wherever you see the grape bunch in *shadow,* add a bit of Ivory Black into a darkened version of this mass tone (this means more Alizarin Crimson and Raw Sienna). Use this also for the shadows on individual grapes. These grapes are also

affected by gray reflections and highlights. Make sure your *Highlights* of gray #2 on the VALUE SCALE are never in the middle of each grape. Observe carefully how the light affects each grape in its position in the bunch. The *haze or reflections* are best added when the painted area has dried somewhat.

Now for that translucent effect: Mix Alizarin Crimson and Grumbacher Red into some white (two shades *lighter* than your shadow color) and paint a little half-mooned shape reflection into the shadow of some of the grapes. It's *important when painting grapes* to paint in some dark, gray areas of Alizarin Crimson into gray #8 on the VALUE SCALE to represent the spaces between the grapes. CAUTION: If this isn't done, your bunch will look like an overgrown raspberry.

> *Helpful Hint:* Whenever painting something yellowish green, always **pull your yellow down** into your mixing area and then **add the green to it,** since nature's greens are more yellowish than tubed greens are.

BASIC EXERCISE

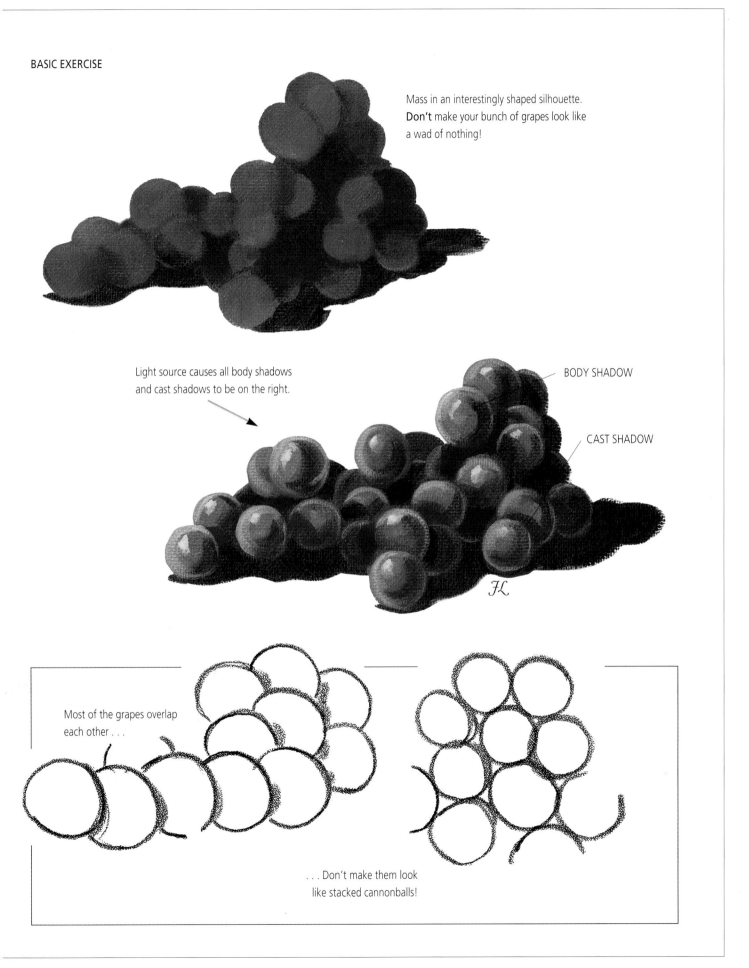

Mass in an interestingly shaped silhouette.
Don't make your bunch of grapes look like
a wad of nothing!

Light source causes all body shadows
and cast shadows to be on the right.

BODY SHADOW

CAST SHADOW

Most of the grapes overlap
each other . . .

. . . Don't make them look
like stacked cannonballs!

More Types of Grapes

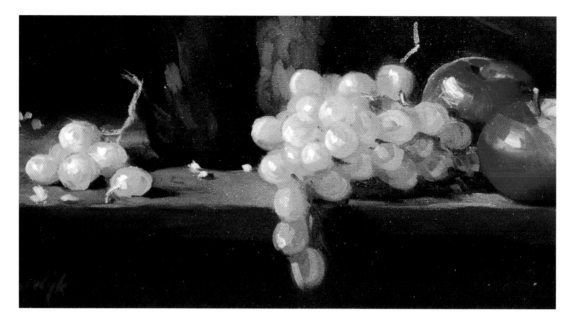

3. GREEN GRAPES.

Follow the same procedure used for Tokay.

4. CONCORD GRAPES:

Very similar to the big purple ones, except they're smaller and the reflections are more bluish. Squeeze out some Cobalt Blue to help you get the correct gray-blue that may be more difficult to get.with the dark, intense Thalo Blue.

CAUTION *(applies to painting all grapes):* The outer silhouette of the entire bunch can't be sacrificed by your involvement with each individual grape. Start by massing in *the entire shape* of the bunch, and carefully observe the grapes that make it up by seeing where the light strikes those *toward* the light and shadows those *away from* the light. You'll see only partial views of many of the grapes and only the ones in direct line with your vision will be seen in their entirety. This overlapping of one grape over another presents a feeling of solidity and dimension.

5. HAZE ON PURPLE GRAPES

Dark purple grapes, such as Concord, have a haze that makes them look beautiful and appetizing. To get a good likeness of purple grapes, you will want to put the haze on. There are two approaches to painting this important characteristic of purple grapes:

FIRST METHOD — LOTS OF HAZE:

STEP 1. Mass in the entire silhouette of the bunch in a mixture of Ivory Black, white, and Burnt Umber (sounds strange, I know) to a value a little lighter than the grapes. This odd mixture will prevent you from making the grapes look poisonous purple.

STEP 2. Now mix Alizarin Crimson, a touch of Thalo Blue or Ultramarine Blue, and a touch of Burnt Umber, and shape each grape that's part of the entire bunch. This mixture will join the mass tone, relegating the mass tone to somewhat of the haze color. Now, mix a lighter tone of STEP 1, and add some Cerulean Blue to accentuate the haze wherever you see it.

STEP 3. Naturally, there'll be a highlight and reflection which you'll have to add. You'll find that some grapes in the bunch will appear to be more reddish. Only your eye can flavor these characteristics.

SECOND METHOD — LIGHTER HAZE):

STEP 1. Mass in the silhouette of the bunch in a mixture of Ivory Black, a little white, Alizarin Crimson, and Thalo or Ultramarine Blue. You're after a dull gray violet.

STEP 2. Mix a warm gray of Ivory Black, white, Burnt Umber, and a touch of either Thalo or Ultramarine Blue and shape the grapes of the bunch with this mixture that's lighter than the mass tone. You'll see this haze very much on the outline of each grape. Add more white wherever you see a highlight. Use a Cerulean Blue and white mixture to fuse your highlight color to the mass tone.

Helpful Hint: Remember, when adding a light tone to an already applied dark area, aim your brush, paint your stroke, and DON'T TOUCH IT AGAIN!!

Lace

The painting of lace turns up in portraiture and also in still life. Japanese fans and lace-lined handkerchiefs are two examples. The procedure for painting lace, incidentally, can be applied to painting fringe.

STEP 1. First paint the background that the lace goes over. Paint into that area a darker tonal version of the lace color in the pattern that it makes against the background.

In order to do this you might have to blot the background color by using a Turkish cloth that you place over the area and pat gently with your fingers. This blotting action removes the excess paint without smearing your drawing.

STEP 2. It's very important when painting lace or fringe to paint it first darker in color than it is. This darker value, in combination with the lighter tones you add, will make the lace take on dimension instead of looking pasted on.

STEP 3. Onto the initial darkened version, add lighter lights to put the lace into sharper focus.

STEP 4. You may be tempted to use a small round brush. *Avoid this temptation.* It's much easier to use a #14 red sable Bright (chisel edge) or #8 of my Overture brushes. Load the end of the brush with some paint and lay the paint on rather than the stroking action that a smaller brush seems to make you use. *Don't touch it again!*

It's obvious that these examples of lace textures are details of two of my portraits. What, then, are they doing in this still life section? Lace is lace, whether it's on a person or on a tablecloth. Doesn't this prove out what I've been espousing all of these years? Without a knowledge of the procedure for painting lace, I'd never be able to include this into my portraits.

I say this in answer to the many portrait students who, through the years, had balked at any attempt to learn still life painting. In my classes, balking got them nowhere. They all studied how to paint the many textures found in still life subject matter before they got a live model. I've always been indebted to Rasko for his uncompromising approach to teaching me portrait painting. May I suggest that you re-read the anecdote that I related on page 67?

Peaches

Along with plums, grapes and cherries, peaches can be added into a more formal type of still life painting. On the other hand, apples, bananas and sometimes pears, make a more informal, homey picture.

The grayness of the fuzz on a peach presents a color problem that can be solved two ways:

The Direct Way: Tone all your color mixtures down by putting them into a puddle of light gray, made of Ivory Black, white, some Green Earth or some Cobalt Violet.

The Indirect Way: Paint the peach's color rather brightly and then paint over these bright colors with a greenish gray (Ivory Black, white and Green Earth). Be careful to drag the greenish gray over the colors without moving the colors too much. You'll find that the gray is more visible around the periphery of the peach, which also helps to make the outline of the peach seem to be less than sharp.

THE COLORS:

If the peach's color ranges from yellowish-green at the stem to orange and then to a rather deep red, start the peach with a mass tone of orange, the medium-toned color. This could be a mixture of Yellow Ochre, Cadmium Red Light with white and a little Cadmium Orange.

Put some Grumbacher Red into that color and paint this mixture where *the peach seems to be getting redder.*

Clean your brush of this mixture and then take some more Grumbacher Red and Alizarin Crimson and mix them into the previous mixture. Now, paint this color into the already reddened area,

For the yellowish part of the peach, add Cadmium Yellow Medium into the first mixture. You may need a touch of white in this. Use Thalo Yellow Green for the yellowish-green areas around the stem.

The whole peach is now covered but some of the areas have to be shadowed. *Make the shadow color* by adding a little black, a little Chromium Oxide Green and a little Alizarin Crimson into the basic orange color. This mixture should look gray violet. Paint this into the already painted peach wherever you see the peach falling into shadow.

Because of the peach's fuzz *the highlight* is very muted and can be made by putting a little white into the yellowish orange mixture, or by just using gray (Ivory Black and white).

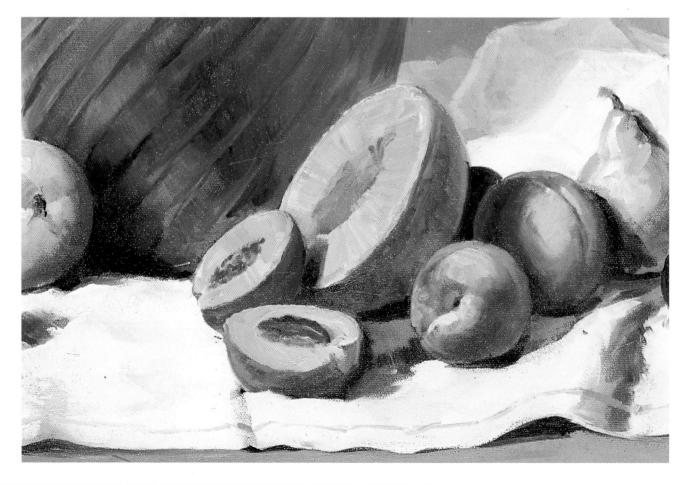

Pears

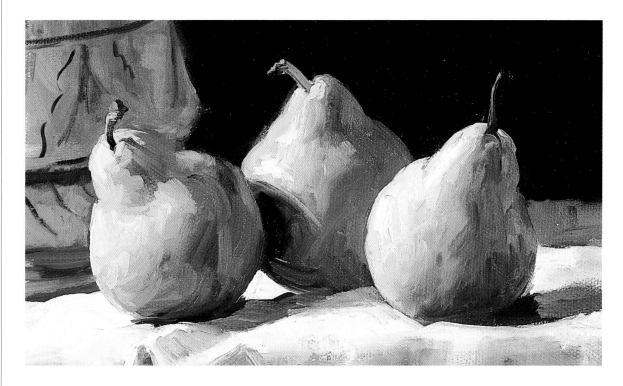

All fruits are fun to paint. Each one presents its own peculiar problem. Apples pose a *color problem;* peaches a *texture (fuzz) problem;* and pears are difficult to paint because of their *shapes* — a combination of a ball with a cone sitting on top of it. Whenever two shapes join, as in the case of pears, the painter, who's placing this object on a flat surface, must call on the help of a *found-and-lost line.*

The *lost line* is where the periphery is a *fuzzy* or a mushy edge; the *found line* is where the periphery *butts sharply up* against the background. The lost line in a pear is evident where the cone top joins the fat, rounded bottom. The manipulation of the paint to form the pear's periphery is more difficult than the pear's color.

To get this correct edge, paint the background color into the shape of the pear. Now, with a darker version of the pear's actual color, move this color out over the background to paint the pear's true shape. Start at the middle of the pear and move out to the edge so the entire pear's edge is lost.

Next, with the true color of the pear, paint the pear again, sharpening the edges where you see them sharp. Leave the initial mass where the lost line seems to appear.

PEAR COLORS:

Most pears are yellowish green. A good *mass tone* is Thalo Yellow Green with Manganese Violet. Yellow Ochre with a little Viridian is another good mixture. And yet another mixture is Cadmium Yellow Light with a little Ivory Black. To paint the mass again for a truer color of the pear, add a little white to any of these mixtures.

For the Shadows: add Ivory Black and Alizarin Crimson to the original mass tone color.

For Reflected Light: some Raw Sienna and Thalo Yellow Green.

For the Lighter Lights: Cadmium Yellow Light, white, and a breath of any green.

For the Highlight: white with a whisper of Alizarin Crimson.

If the pear is flecked with brown, don't make these brown spots too dark. If there's a slight pinkish look, add Cadmium Red Light into the true pear color. But because Cadmium Red will darken this mixture, you'll have to add some white.

Helpful Hint: Make sure you place the pears in a good-looking position, one that's easy to paint and also shows the characteristic of pears.

Green Peppers

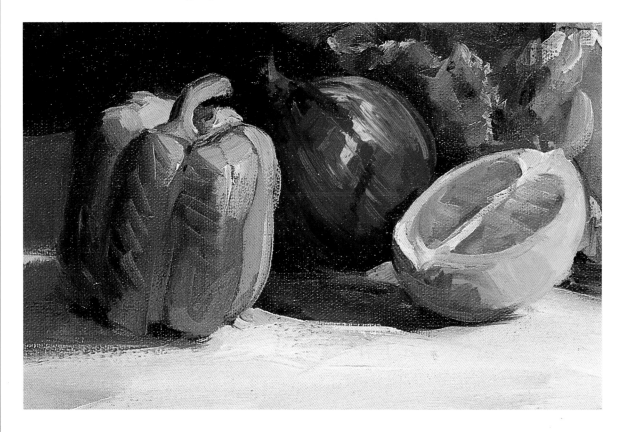

Green peppers, on so many occasions in still life painting, add a welcome relief of shape and color. Their silhouettes are more square than the vegetables they're usually painted with (like onions, tomatoes, and radishes) and the coolness of the peppers' color is a relief from the other warmer colors. Also, in an arrangement of vegetables, the dark value of green peppers injects interesting accents. So, let's paint green peppers.

STEP 1. Mix Thalo Green, Burnt Umber, and a little Cadmium Yellow Medium together. This mixture represents the mass tone of the green pepper. *Don't mix it too light.*

> **Helpful Hint:** *Never look for the mass tone color of the object where the light strikes the object. The mass tone is better found in the area* **just before the shadow.**

STEP 2. Apply this mixture to the area where you want to record a pepper, using the color to paint the pepper's silhouette.

In massing in the pepper, start applying your paint in the interior of the silhouette, and wipe your brush of color when nearing the outline of the pepper. It's better to keep the paint sparse near the edges so later the shine of the green pepper can be more easily obtained.

STEP 3. Before trying for this waxy look it's better to paint in the shadows. Do so by mixing a little bit more Thalo Green into your basic tone and add a touch of Alizarin Crimson.

STEP 4. You'll notice on most peppers some lighter, brighter yellowish greens appear where the light strikes. This color is easily gained by mixing Thalo Yellow Green into the mass tone color. It also can be mixed by putting a little Thalo Green into Cadmium Yellow Light.

CAUTION: Try not to make these lighter additions too raw looking. If these lighter mixtures seem too bright, tone them down with a little Cadmium Orange.

STEP 5. The highlight on a green pepper is a light gray. Mix Ivory Black and white and add a little bit of Thalo Green and some Alizarin Crimson. Mix this light gray mixture to look like a very pale, dull violet.

STEP 6. The gray haze is the same mixture as the highlight except darkened with some black. Saturate a brush with the "haze" (but using no medium), then wipe the brush with a rag, and drag this color over the pepper, usually around the edges to impart that waxy shine.

Pewter

Pewter is seemingly colorless. For this reason, it has to be painted with colors that are grayed.

Mass Tone: A warm gray of Ivory Black, white and Burnt Umber.

Shadows: Add more Burnt Umber to the mass tone and add a touch of Thalo Blue or Ultramarine Blue.

Darkest Darks: Burnt Umber and blue, but predominantly Burnt Umber.

Highlights: White with a touch of either Thalo or Ultramarine Blue. Or white with a very slight bit of Alizarin Crimson. Mush the highlight mixture into the mass tone and then apply the highlight mixture again. This produces the slight gradation toward a highlight that's so typical of pewter.

Reflections: Mix your background or surrounding area color into gray (Ivory Black and white) and apply wherever it's seen on the object, usually in the shadowed areas.

REMEMBER: the pattern of the highlight on any metal object describes the object's shape in depth. Highlights are on any place where the shape is directly in line with the light. In very simple terms: *Highlights fall on all the bumps and dents.* Don't arrange your lighting in a way that will make these important highlights fall on the middle of the object.

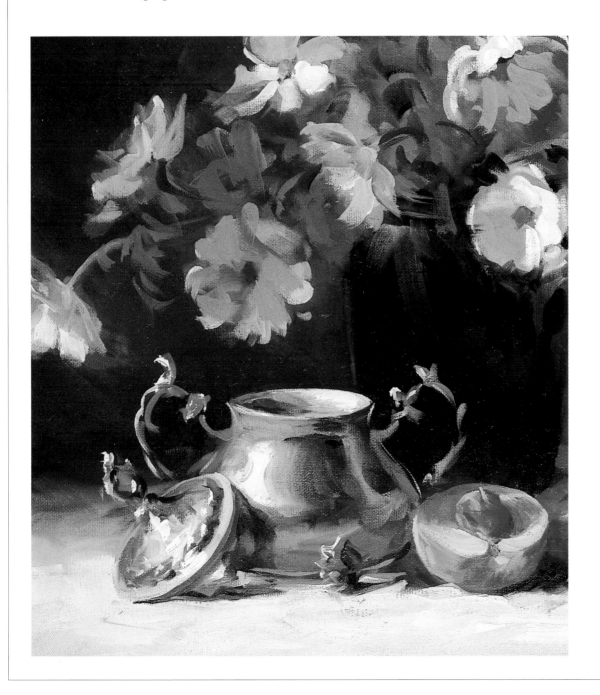

Silver is much like pewter but its tones are in sharper contrast. Because of this it's easier to paint than pewter. The mass tone of silver is determined by the color of its background. It's usually complementary to the background color. In this *Color Recipe* I'll suggest colors of silver as seen against a green background.

Mass Tone: Ivory Black and white and a little bit of Alizarin Crimson, making a slightly violetish gray. If this mixture looks too violet, mix in a touch of Viridian (the complement to reddish Violet).

Shadows: Add more Ivory Black, Viridian, and a very little bit of Alizarin Crimson to the body tone.

Highlights: A little bit of Yellow Ochre into a lot of white.

Light Reflections: Into light gray, add Viridian and a little Cadmium Yellow Light.

Other reflections: A shiny surface like silver is sure to reflect colors that are nearby. For instance, a red book will be reflected on the planes of the silver object that are in line with the book.

The darkest dark tones: Thalo Green and Alizarin Crimson.

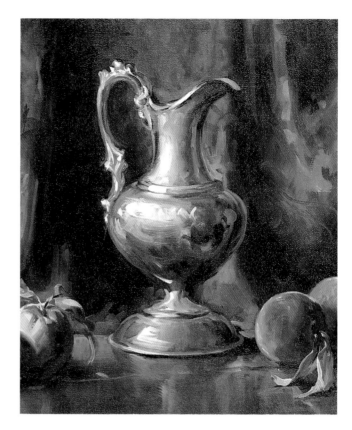

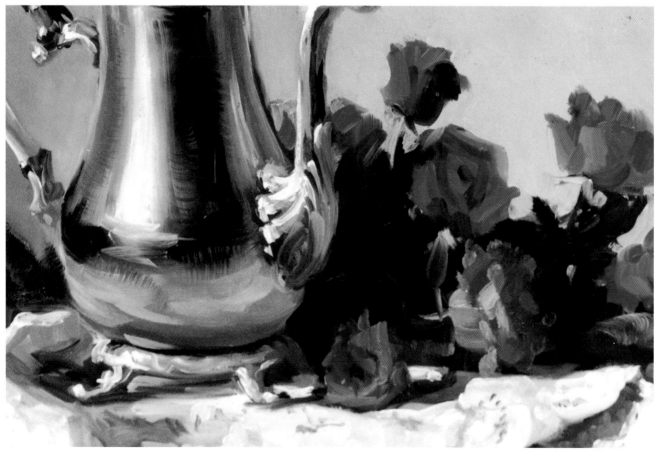

Black Skillets and Pots

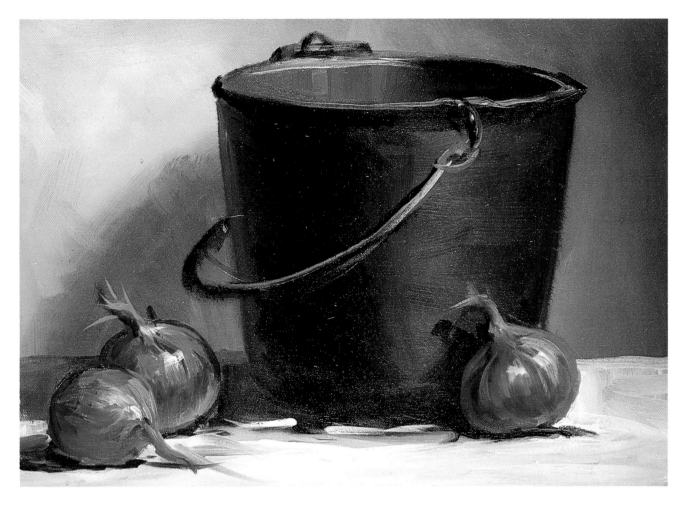

You may think that black skillets and pots are obscure and colorless as subject matter for paintings. But the most commonplace can be very intriguing. A long narrow picture of a black skillet with some garlic blossoms and cloves, or a black pot with some red onions, would be a painting challenge and would make an interesting composition.

Through use, a black pot assumes many colors:

It can be *rusty and encrusted.* It can be *shiny in places.*

Its texture seems to change according to where it's been handled and where it's been close to the fire.

STEP 1. In the drawn-in area of the pot, mass in a more exaggerated color than what you observe, such as:

Where it's rusty — Ivory Black and white and Venetian Red.

Where it's dull — Ivory Black and white and Burnt Umber.

Where it's shiny — Ivory Black and white and Cerulean Blue.

Where you can't distinguish any definite color — Ivory Black and white, Burnt Umber, and Thalo Blue (more toward Umber).

At this point you should have an exciting array of semi-dark grays. Now, fuse all these colors together by using a large, dry brush. Make your blending stroke respect the planes of the skillet, such as *down strokes* for the sides of the pan; *across strokes for the flat bottom.*

STEP 2. Wherever you see the pot very dark, mix Thalo Blue and Alizarin Crimson.

Stone Crocks

Today, more and more people are frequenting antique shops. No matter where you may be in this country, you'll always run across some variety of stone crock. As still life subject matter these objects are ideal. They come in many shapes and sizes, and can be used as a focal point or as an addition in a still life.

A storage type crock can be used with apples or onions or any of the vegetables that can be pickled. The crocks that once were used to store wine and whiskey can be placed in an arrangement with fruit.

STEP 1. Basically, the color of crocks is yellow. This can vary from *quite light,* (the color of tan or beach sand) to crocks that are accented with a very *dark* glaze of *rich brown* (generally found in bean pots). Since the yellow family's the easiest to paint in, these stone crocks shouldn't be hard to record. Of course, be very aware of the construction of the crock; you've got to make your paint record this. A good way to become better acquainted with the stone crock you're going to paint is to close your eyes and feel the crock from the top down. Count how many times your fingers change directions. This will tell you how many different planes you'll have to record.

STEP 2. *The color mixtures:* Mass the stone crock in with the *darkest color* you see on the *light side.* A way to find this tone is to take pure white and put it where you see the highlight so you can mix enough color into white to get the mass tone correct. If your stone crock's a gray-yellow, mix either Yellow Ochre, Burnt Umber, or Burnt Sienna into a light gray of Ivory Black and white. If your crock isn't that grayed, use more Yellow Ochre, Burnt Umber, or Burnt Sienna into a *lighter* shade of gray.

STEP 3. Add Ivory Black and Alizarin Crimson to the basic tones for the *shadows,* and into that mixture add Raw Sienna for the *reflected light* in the shadow.

STEP 4. Now, add Yellow Ochre, Burnt Umber, or Burnt Sienna, depending on the hue of the crock, into white and build the lighter side up lighter.

STEP 5. *The highlight:* white with a little Alizarin Crimson.

For crocks that are accented with very dark brown, use a mixture of Burnt Umber and Burnt Sienna as a mass tone. Add Alizarin Crimson and Thalo Blue for the very *dark* reflections. Use gray-violet or gray-blue for the *light* reflections, and a very light gray -violet for the *highlights.*

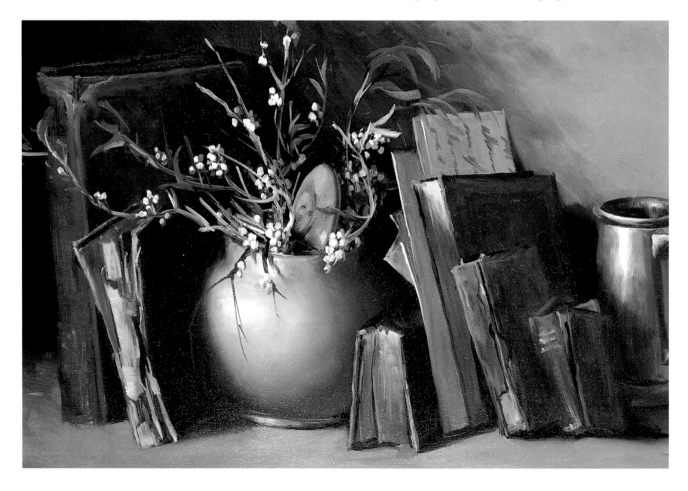

Table Color

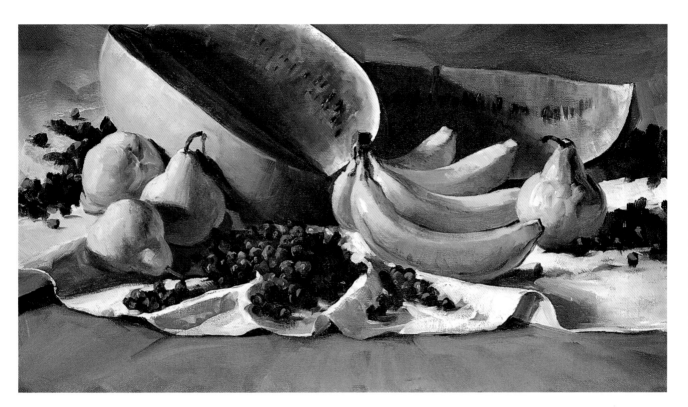

1. The table color should be *lighter* as it goes farther back; *darker* as it meets the frame's edge at the bottom.

2. The table color can't be raw or bright; it must be grayed. You can do this by including Ivory Black and white in the type of brown that's the table's color. A good general table color is — Ivory Black, white, Burnt Umber, and a touch of Burnt Sienna. *For maple* — add more Burnt Sienna; *for mahogany* — add some Alizarin Crimson. Using a grayed color will make the light look like it's glaring on the table, thereby making the table appear to go back into the distance.

3. Don't add horizontal darker streaks to show the grain; they usually look more like lumps or worms. If you want to show a grain (when painting wood, who doesn't ?), let the table color dry, then *glaze* a grain pattern over the entire area. Use Burnt Umber thinned with a medium and apply with a very large, soft-haired brush.

4. Realize that your foreground is trying to create the illusion of atmosphere as much as your background is. Include, then, some of your background color into your table color. It's one way to unify the feeling of atmosphere.

5. The pattern of the cast shadows from all objects that rest on, your table should be treated carefully and beautifully. These cast shadows are complementary to your table color. Therefore, I can say: generally, *cast shadows on table colors are almost always dull violet* — any blue and Alizarin Crimson mixed into your table color.

OAK TABLES:

Since tables in still lifes represent the atmosphere between the picture's viewer and the subject, they are illusive to paint because they have to be atmospheric tables. Basically, the table's tone is lighter in the distance and darker as it comes towards the frame's edge at the bottom of the picture.

Mass Tone: Make a medium-toned gray (Ivory Black and white) and add Burnt Umber and Burnt Sienna. Apply this mixture over the table area.

For the table area *as it meets the background,* lighten the general mixture with white. For the table area *where it meets the frame's edge,* add Burnt Umber, a little Alizarin Crimson, and Ultramarine or Thalo Blue into the general tone.

Any cast shadows on the table from objects resting upon it are Burnt Umber and blue (Thalo or Ultramarine) with a little Alizarin Crimson, with a stress on more violet than Umber.

Reflections

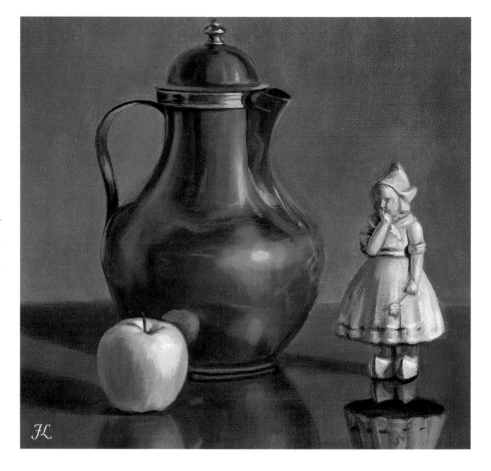

Remember: A correct cast shadow can always anchor a floating object.

STEP 1. Mass in the entire dark table in a basic brown tone of Burnt Umber, Ivory Black and white, Alizarin Crimson, and a touch of Ultramarine or Thalo Blue. Where the table goes back into the distance, add more gray (black and white) to this mixture to lighten it, making the massed-in table lighter in the background, darker in the foreground.

STEP 2. Where you see *lighter* colors reflected in this table color, add that lighter mixture into the table color on your palette. *Paint these reflections with vertical strokes on the canvas.* This makes the reflections look like they are going into the depth of the wood. If you see any *dark reflections,* use Alizarin Crimson, Burnt Umber, and Thalo or Ultramarine Blue. Paint these dark reflections *also* in a vertical direction,

All the reflections from light objects have to be darker in tone than the objects themselves. For instance, if a yellow apple that's made of Yellow Ochre, Cadmium Yellow Medium, and white were reflected on the table, its reflection would be painted with *Yellow Ochre only,* which is darker than the apple color. Reflections from dark objects are *also* darker than the objects. This happens because the colors of the object when mixed into the table color *have* to make the object's reflection darker.

STEP 3. Remember: your background color's also going to affect this shiny table, so the background color has to be put into the table color with vertical strokes wherever it's seen.

STEP 4. Now, with a wide, soft, dry brush blend the reflections into the table color with light but long *horizontal strokes.* This blending process will show the grain of the wood and will also put the reflections in their place. If this horizontal blending process isn't enough, use this brush in light vertical strokes over the entire table. Then stroke horizontally again.

STEP 5. Finally, with Alizarin Crimson and Thalo Blue add the cast shadows that you see under the objects; they make the objects sit on the table.

Helpful Hint: All your reflections at this time should be painted more obviously than they really are. **Be bold with your colors and your application!**

BASIC EXERCISES

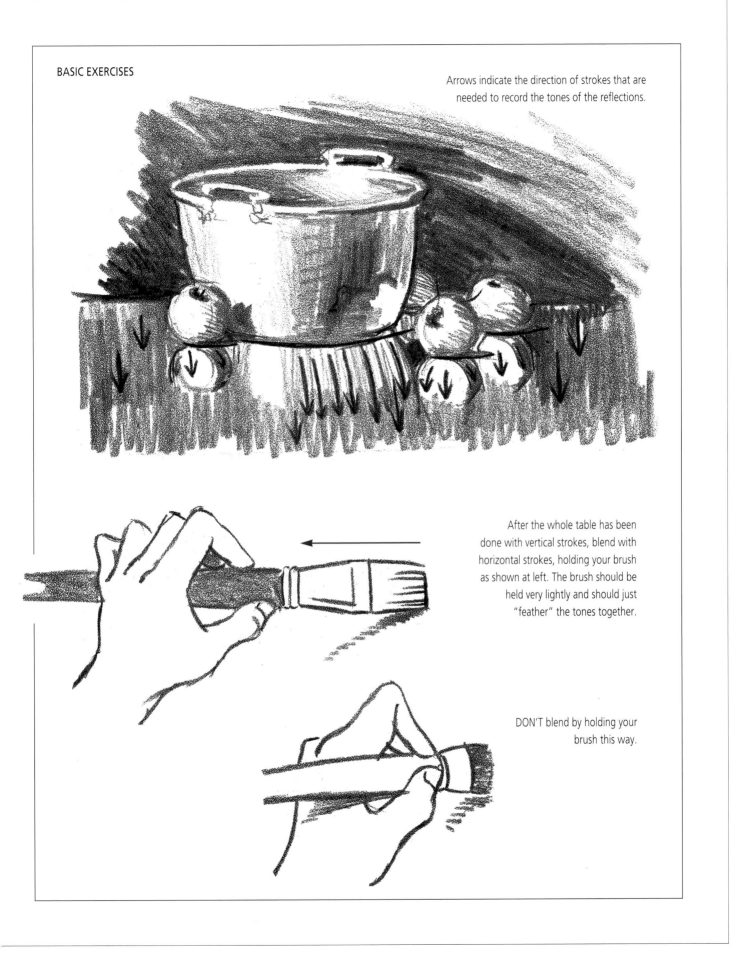

Arrows indicate the direction of strokes that are needed to record the tones of the reflections.

After the whole table has been done with vertical strokes, blend with horizontal strokes, holding your brush as shown at left. The brush should be held very lightly and should just "feather" the tones together.

DON'T blend by holding your brush this way.

Tomatoes

A still life of green peppers, a head of lettuce, and tomatoes with a few radishes makes a charming picture for kitchen, breakfast nook, family room, or informal dining room. For accent, you can add an interesting vinegar cruet or a pepper mill. The trick to painting a successful tomato is to *make the skin shine.* This shiny quality is most dependent upon a successful highlight.

Mass the tomato in with Grumbacher Red with some Alizarin Crimson. Add a touch of Chromium Oxide Green to this mixture to impart *the shadowed areas.*

So often a tomato gets an orange coloration near the stem area. Take Cadmium Red Light and a little Cadmium Orange, load your brush with this mixture, and pile the shapes of these more orange hues, thus forming the anatomy of the stem area.

The All-Important Highlight: Where the highlight will be, wipe the red color away with a cloth. Paint in the highlight with white and a little Ivory Black in it, making a very light gray. With a soft brush blend the red and the light gray together. Into this lighter grayed area, plant a highlight of white with a mere touch of Thalo Green in it.

Finally, accentuate the shadow with Alizarin Crimson, Grumbacher Red and a touch of Thalo Green.

Helpful Hint: If the highlight doesn't look right once it has been painted, **wipe it out** and repeat the procedure. **Don't pick around with a wrong highlight!!** And don't spread the highlight out to be too large!!

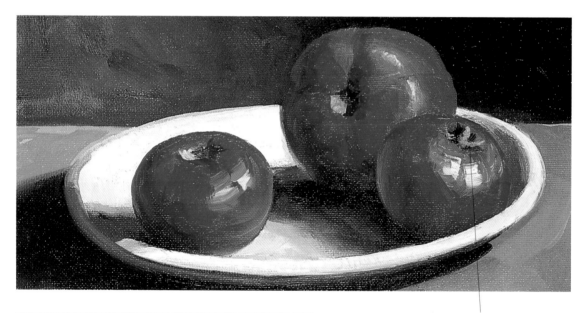

On any fruit, paint the stem area and stems last.

Watermelons

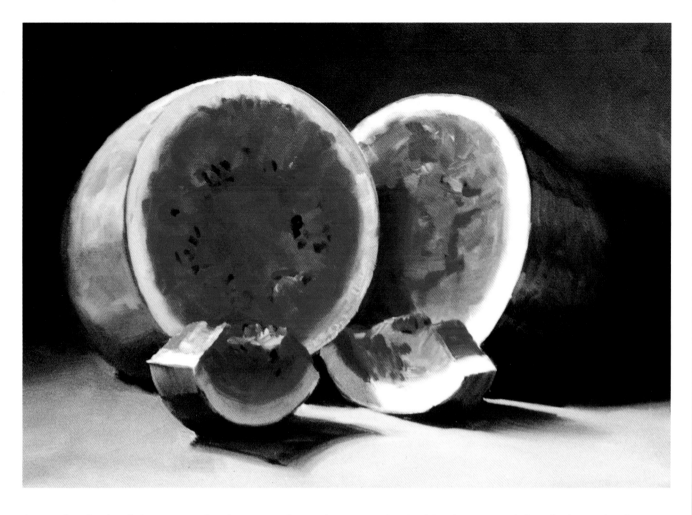

Arranged with other fruit, a watermelon (cut open, of course) makes an intriguing subject. But you can also use watermelon alone in a composition — cut in half, in wedges, etc., you'll find you'll get a variety of interesting patterns. The difficulty in painting watermelon is to correctly get the *red to meet the white rind.* To do so:

STEP 1. Paint the light part of the rind first with Thalo Yellow Green and white.

STEP 2. Take Cadmium Orange, a little Grumbacher Red and white and paint the area where the red meets the light green color. Making the yellowish-green color *larger than you see it* will give you the chance to mush the orangy-red color into it.

STEP 3. For the meat of the melon, use Cadmium Orange and Grumbacher Red. And where you see the red meat get very ripe-tip this mixture toward Grumbacher Red with maybe some Alizarin Crimson.

STEP 4. Where you see the seeds, paint in a darker tone of Grumbacher Red, a little Alizarin Crimson and Burnt Umber. Where the seeds are, you'll notice, there's a whole darker value within which you'll find dark spots for individual seeds. *Don't make these seeds too dark.*

STEP 5. To make the watermelon look wet, drag over the red areas with a mixture of white that's been grayed with Viridian and a touch of Cadmium Orange.

STEP 6. Now, with Viridian, add more green to the yellowish-green rind where it meets the outer dark green skin.

STEP 7. If any of your slices are in shadow, shadow your red by using Grumbacher Red, a touch of Alizarin Crimson and some Viridian or a touch of Thalo Green.

Velvet

Although this recipe is for black velvet, the procedure can be used for any colored velvet.

STEP 1. Mix a dark gray, made of Ivory Black, white, Alizarin Crimson and Thalo Green in a tone that's #8 on the VALUE SCALE. Paint this mass tone over the area that's going to be the black velvet. *Don't make this mixture too thick or too thin.*

IMPORTANT: Use brush strokes of short jabs; they'll make your paint look more like velvet than if you use long strokes. Use the same short jab-strokes when you add your other values.

STEP 2. Mix Alizarin Crimson, Thalo Green and Thalo Blue, and use this tone to put in any shadows that you see. Most likely, a shadow's there because of a fold. This shadow tone should be stroked on in a direction that's opposite of the fold's direction. If your fold's hanging from the top of the canvas, your strokes should go from side to side.

STEP 3. Add a little white and Burnt Umber into the basic tone mixture to make a warm gray. Load the end of the brush and pat this on wherever you see the light striking the edges of the folds.

Helpful Hint: *Whenever you paint a dark drape, you'll find it will have a richer color if you do the drape in two applications. If the drape you're painting is to be dark red, mass the canvas the day before in a thin application of a mixture of Burnt Umber, Thalo Blue and turpentine. This mixture will dry overnight to enable you to paint your dark-toned canvas.*

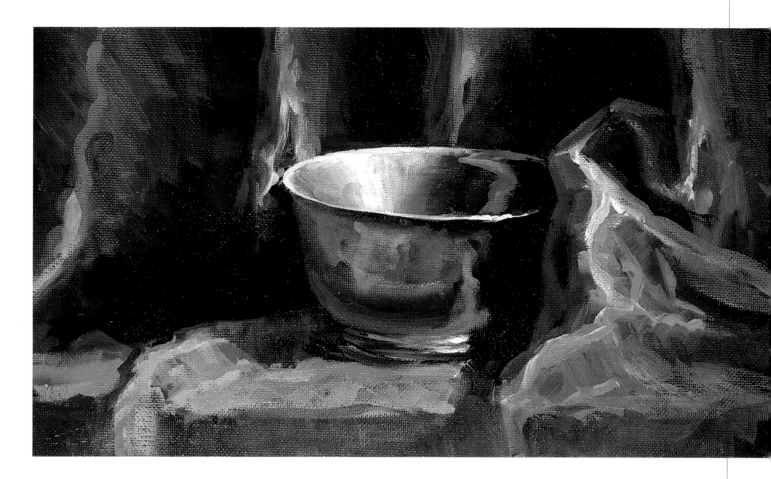

BLUE VELVET DRAPERY

This fabric provides a nice background for statues, for silver,or pewter, and even is nice on a table with books and candlesticks.

STEP 1. If a *dark blue,* mass the entire velvet area in with a general tone of Thalo Blue, Cobalt Blue, white, and a little Burnt Umber. For a *lighter blue,* use more white; for a *greener blue,* add a touch of Thalo Green.

Massing in should be done with strokes no longer than a half-inch. This helps to give you the thick look of velvet. Also, vary the tone of the application a little to give the appearance that the pile of the fabric is either crushed or crisp.

STEP 2. With a lighter, brighter version of your mixture (omitting the Burnt Umber), dab into the mass wherever you see it lighter. Use the same short strokes.

STEP 3. Where you see the shine caused by the folds, use quite a light gray-blue: light gray (Ivory Black and white) with Thalo Blue and Thalo Green. Scoop up an amount of paint by pushing your brush into the puddle so that you've loaded the end of your brush with paint. Then, pat the color in a line to represent that lighter tone value.

STEP 4. Make the shadows on the velvet by adding a little more Thalo Blue into the mass tone color, and then adding Burnt Umber to tone the color mixture down in intensity.

Red Wine in Clear Glass

Suggestion: Make the glass of wine an addition to an already painted area, preferably after the paint has dried. With chalk or with light gray paint (Ivory Black and white), very much thinned with turpentine, sketch in the glass by indicating the top ellipse, the stem, and the base.

Mass in the wine with Alizarin Crimson(for Rosé add a little Grumbacher Red to the Alizarin Crimson). Where you see the flat plane of the wine, paint this elliptical form by adding gray and Cadmium Red Light into the Alizarin Crimson.

REFLECTIONS OF LIGHT IN THE WINE ARE TWO TYPES:

1. **Gray reflection.** Made with black and white and a touch of Cadmium Yellow Light, this will produce a greenish gray.

2. **Bright, light red reflections.** Mix a lot more than you need of Grumbacher Red and white, load the brush and pile the reflections onto the already painted color. This prevents it from mushing into the mass tone and dulling the reflection. You can also make this bright red reflection with Thalo Red Rose and white, or Cadmium Red Light and white applied thickly.

To wrap the glass around the wine, add a highlight of Yellow Ochre and white to the front and back of the upper ellipse. Drag the front highlight down from the ellipse over the wine color. Now, with a little more Yellow Ochre in the mixture, add the reflection seen on the side of the glass that's opposite to the source of light.

With gray and a little bit of Chromium Oxide Green, add any dark reflections that you see on the glass, especially on the stem and the base. Add highlights of Yellow Ochre and white to the stem and the base.

Helpful Hint: Highlights are more successfully put on with **undiluted paint,** much like the reflections.

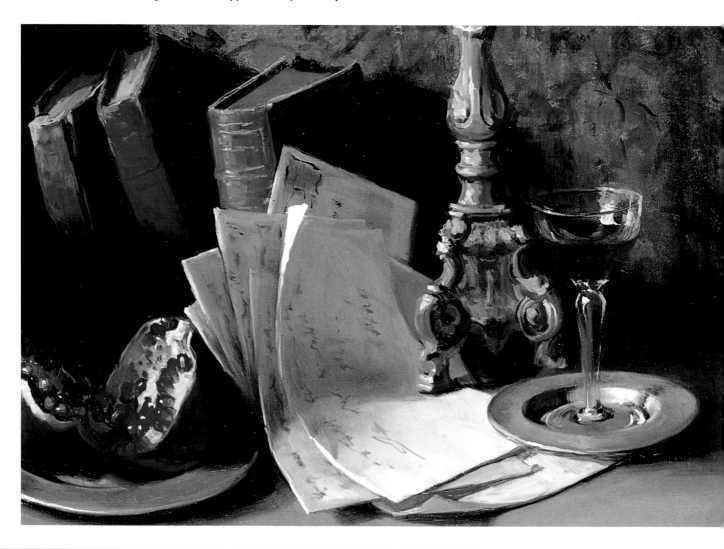

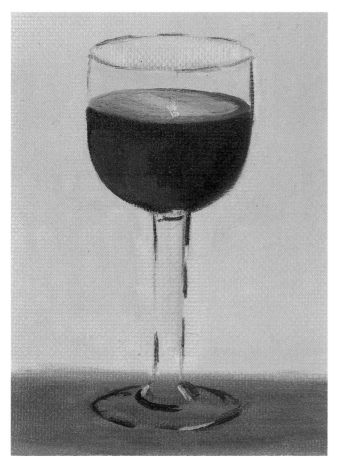

The dotted lines merely indicate where the glass is. However — don't paint it in.

Start by just painting the values of the wine.

Add the values of the glass itself: the darks and the all-important highlight pattern.

Make the highlight that appears on the front of the glass by starting at the rim and pulling the paint down over the wine area. This makes the wine look like it's in the glass.

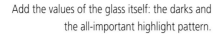

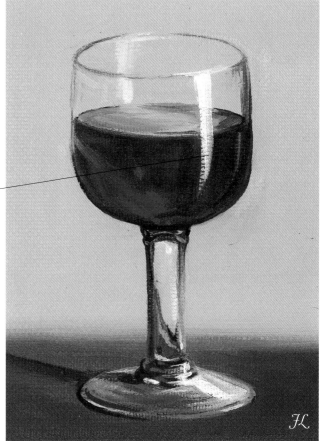

White Cloth on a Table

Most often, any white subject matter should be massed in a *warm* version of white because lighting usually presents a *warm condition*. This mixture could be white with a touch of Ivory Black and Yellow Ochre, or a touch of Burnt Umber or Raw Sienna. Even if the cloth lies flat and you see no folds, you should paint the cloth area twice. First, paint it in with the *off-white mixture* I've just given you; then impart to it a *lighter* mixture of white and Yellow Ochre. This will give the cloth a feeling of body and substance.

Whenever you see a shadow, whether it's a cast shadow from an object or the shadow caused by a fold, make a mixture of a gray made of Ivory Black and a little Alizarin Crimson mixed into the basic tone.

Into your *shadow* mixture, add a little Raw Sienna and a little white and impart this slightly lighter value into your shadows for a more luminous effect. It's very important when painting a white cloth on a table to use a mass tone that's not too light. You want to save the lightest value for wherever any folds are lumped up and therefore are catching the full illumination.

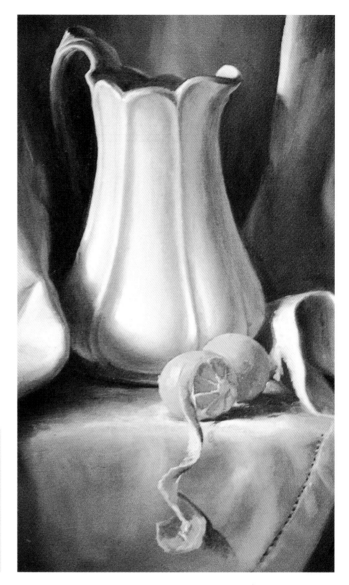

Helpful Hint: Arrange the folds and only paint the folds that you see around the subject matter. If you paint little dark shadows that are **not attached** to the subject, they'll have no meaning and will look like dirty spots.

Index

Helen Van Wyk Teaches on Video

Helen Van Wyk has been immortalized on videocassette, which you'll want to own to study over and over again in your home. Each video teaches a phase of the painting process that is a tribute to the teaching mastery of Helen Van Wyk. In each video, you will learn the techniques and procedures that have made Helen a favorite among students and art connoisseurs. While Helen tragically is no longer with us, her philosophy about art and painting instruction will live on forever. These videos present Helen in modes very much like those she exhibits in her nationally known television show, WELCOME TO MY STUDIO, except in each video, she enjoys the luxury of extra time, and can embellish her instruction.

Brush Techniques: Your Painting's Handwriting

Universally recognized as the most important tool in painting, the brush remains a mystery in the hand of a painting beginner as well as in more experienced hands. In this one-hour video, Helen demonstrates how versatile brushes can be when used properly. First, she guides the viewer towards using the right brush for the right job, then moves into the area of achieving different textures and effects to benefit each painting you do. Helen's instruction includes the all-important proper way to clean your brushes, a successful departure from the method that has been taught in art schools over many decades. Every artist should own a copy.

Painting Children from Photographs

Everyone wants to paint children but can't make them sit still. After years and years of painting children, Helen says, "never make them pose for you. Just photograph the little darlings." This video shows you how to go about it. Helen tells you what kind of photographs are best suited to use as models. And once you're set on one, she explains, in easy-to-understand instructions, how to transfer it to canvas through the grid method. There's much more in this one-hour presentation: preparing an underpainting, applying glazes and also the technique of *alla prima* (direct) painting. At last, you can paint the child in your life without fuss and stress.

Elegant Abundance

During the 16th and 17th centuries, Dutch still life painters were producing masterpieces that were emblematic of the so-called Age of Elegance. In this 90-minute video, Helen recaptures that era with her superb still life that bursts with subjects and textures: lemons, silver, lobsters, glass, flowers, and more. Hence, the word "abundance" in the title. If still life is your painting passion, you absolutely have to own this stunning vehicle of instruction. It will help you, too, with other facets of your painting production. As Helen had always asserted, "still life is the backbone of good painting." This is the last video made by Helen Van Wyk.

Oil Painting Techniques and Procedures

A two-hour demonstration of a still life. It starts with a monochromatic underpainting and is followed by glazing applications to end with direct *alla prima* touches. Finally, the technique of glazing is fully explained and illustrated. In this still life, you will see Helen paint every kind of texture which will help you with all the subject matter you may encounter in your still lifes. In the composition there is a non-reflective jug, a transparent green glass bottle, a copper pitcher, apples, lemons (cut and whole), grapes, white tablecloth and the all-important background. It is safe to say that an entire painting course resides in this one video.

Painting Flowers *Alla Prima*

Alla prima is an Italian phrase that means "all at once." In this one-hour presentation, Helen demonstrates this direct application of paint to interpret a bouquet of daisies. Starting with four marks on the canvas, to indicate the outer reaches of her composition, she proceeds to build her painting, ending with the highlights. Throughout this video, you will learn how Helen gets her paint moist and juicy, a look that has entranced viewers of her TV show and live demonstrations. Helen Van Wyk is a fountain of information, never shying from dispensing it to all those interested in painting better.

A Portrait: Step-by-Step

One hour of painting a male model. In this video, Helen covers every facet of portrait painting, experience gained from fifty years of painting people. You will learn about mixing the right flesh color, getting the shadow to look just right, and that difficult "turning edge," the area between light and shadow. "Anyone can get a likeness," Helen says, "but the trick is to make the model look human." If portraits are your interest, you won't want to miss this sterling, informative video. Once in your possession, you'll find yourself watching it over and over. You will be amazed at how much it will help you with your portraits.